STORY of the STONE

From
Dream of the Red Chamber
by
Cao Xueqin

Illustrated and Interpreted
by
Linda Ching

STORY of the STONE

Ten Speed Press
P.O. Box 7123
Berkeley, California 94707
www.tenspeed.com

Distributed in Australia by Simon and Schuster Australia, in Canada by
Ten Speed Press Canada, in New Zealand by Tandem Press, in South
Africa by Real Books, in Southeast Asia by Berkeley Books, and in the
United Kingdom and Europe by Airlift Books.

Photography, text, and design by Linda Ching

All translations of prose and poetry by Yang Xian-yi and
Gladys Yang except as noted. Page 55, 71, 89:
Prose translations by David Hawkes from
*The Story of the Stone Volume 1: The Golden
Days*, by Cao Xuequin (Penguin Classics, 1973)
copyright © David Hawkes.

Library of Congress Cataloging-in-Publication Data
Ching, Linda
Story of the stone: a photographic interpretation
of the classic Chinese novel Dream of the
red chamber/illustrated and interpreted
by Linda Ching.
p. cm.
ISBN 1-58008-018-9
1. Ts' ao, Hsüeh-ch' in, ca 1717–1763. Hong lou meng—
Illustrations. I. Ts' ao, Hsüeh-ch' in, ca 1717–1763. Hong lou meng .
English. Selections. II. Title.
PL2727.S2C5534 1998
895.1'348—dc21 98–26725
 CIP

First printing this edition, 1998

Printed in Hong Kong

1 2 3 4 5 6 7 8 9 10 — 02 01 00 99 98

Contents

Acknowledgements

"You're in luck, the Gods are with you!" My Beijing translator Fan Zhilong would say this when he accomplished another seemingly impossible task for me. It seemed to be true. How else could I have amassed such generous support, having just arrived in a foreign country with not much else but a wish list in hand. As this long list acknowledges, there are many to thank and much to be thankful for.

To start, "my angel in Beijing" Mr. Fan, for making it all happen, *xie xie* a hundred thousand times. My gratitude to Yang Xian-yi and Gladys Yang for allowing me to incorporate their sensitive translations of prose and poetry into my text. I'm honored to have Yang Xian-yi's introduction in my book. To Zhou Ruchang, a man of extraordinary scholarship and grace, I am ever humbled by your encouragement and thankful for your contribution. Thank you to Wang Guhua, an authority on the novel of uncommon vision and dedication; Mei Zi, Beijing Beiputuo Film & TV Base, for the most magnificent location to film in and for the models who bring the story alive on these pages; Cao Biao, Assistant Director, and Fang Ping, Producer/Director, Beijing Film Studio, for the exquisite costumes and props. Thank you to Hao Ping, Director, Office of Foreign Affairs, Peking University; and Cindy Ning, Assistant Director, Department of Chinese Studies, University of Hawaii, who trusted my vision and played key roles in bringing this project to fruition. Thank you Jeanette Paulson for inviting me to fly into China on your coattail. Much thanks to Prof. Don Gibbs, University of Peking, and Loretta Gibbs for your guidance and translations but especially for the warm meals and hot chocolate that thawed the chill after those biting cold days. My gratitude and admiration to Zhou Manli, my smart and fearless student assistant who ran interference, kept me on time and on track, who braved the brutal winter photo sessions without complaint and solved every problem of the day. Thank you to Li Ping, production coordinator, and the beautiful dancers from Beiputuo Film & TV Base who portray the characters of the story so exquisitely. My thanks to the two Goddesses, Lisa Kahn and Gin Wong; Liu Dan, stylist in Beijing, and Leslie Galagher, stylist in Hawaii; Ho Hung Wong for the exquisite engraved seals and calligraphy; Dave Lowe, the computer wizard.

My heartfelt gratitude to the following for their input and support: Grace Atkinson, Cecilia Blackfield, James Brock, Caleb Chan, Linda Chan, Andy Chang, Sherrill Chidiac, Donna Dang, Stephen Doyle, Susan Flowers, Donald W.Y. Goo, George Irion, Clifton Kagawa, Dale Krenza, Jose B. Lee, Cal Lui, Warren Luke, Nani Mahoe, Kendall Mark, Tom McGannon, Margaret Pang, Wendall Pang, Barry and Diane Raleigh, Thos Rohr, Kenneth Sandefur, Andrea Simpson, Michele Smith, Cynthia Spengler, Rosemary Townsend, Ross Uchimura, Charlotte Vick, Peter Wiley, Simon Winchester, Howard Wolff, Mun Charn Wong, Penelope Wong, Ron Wright, Valerie Yee and Nola Yee.

Much thanks to the many others who stepped forward in countless ways. Love and thanks to my family, Stephen Ching, Lynell Totoki, Sheila Davies, and Holly Lau, for their love and contributions and to Robin Stephens Rohr for realizing the vision and going the extra ten thousand miles to bring the book to print.

In memory of my mother,
Judy Ge Ching

*With special appreciation to the following
for making this book possible:*

AT&T Hawaii

BHP Hawaii, Inc.

Chan Foundation

Chemtex International, Inc.

Continental Airlines

Finance Factors, Ltd.

Hawaii National Bank

J. Walter Thompson Company, Ltd.

Montgomery Asset Management

Wimberly Allison Tong & Goo, Inc.

in memoriam

Clifford Yee and Barbara Young Yee

Foreword

*H*ong Lou Meng (*A Dream of Red Mansions* or *The Dream of the Red Chamber*) is a realistic, vivid Chinese novel. It is, to put it plainly, a very long story. The 120 chapters compellingly relate the fall of a rich official family in the declining years of the Ch'ing dynasty. Perhaps the most popular novel in Chinese literature, it also enjoys great critical literary stature in China, much the same as Shakespeare's works enjoy in Occidental literature.

The novel was written over 200 years ago by Cao Xueqin. A wealthy and noble family pass their lives in splendid cultivated gardens. Their life of sensual pleasures and the vicissitudes of fortune are recounted—with a leitmotiv intertwined, centered on the love of the young master and his beautiful and delicate cousin.

Some critics believe *Hong Lou Meng* is autobiographical, given the rich detail with which it is told; others believe it to be a political allegory on the old empire's eventual fall. Along with the plenitude of critical literary research comes a fascination with this novel's ethereal quality, intermeshed with its veiled political metaphor.

Until the latter portion of this century only abridged or partial English translations of this book have appeared, under the title *The Dream of the Red Chamber* or *Red Chamber Dreams*. One translation of the complete work was done by the English sinologist David Hawkes, who named his work *The Story of the Stone*; my wife Gladys and I did the other complete translation, naming our work *A Dream of Red Mansions*.

Ms. Linda Ching's artistic interpretive "translation" of the introductory chapters of *Hong Lou Meng* adds an apt explication of its pure t'ai chi chu'an form: a true epitomization of its spirit, but in an ambiance of pure conflict between art

and reality. Through her art we are able to envision the beauty and splendor of classical Chinese gardens, the delicacy of the hero and heroine—yet a tragic transcendence is also visualized. The artist "paints" the tragic fragility of a world that is now only remembered in dreams. I hope you will enjoy this magnificent tribute to Cao Xueqin as much as I have. It may even encourage you to read and enjoy the great literature it depicts.

Yang Xian-yi
Beijing 1997

Introduction

The eighteenth-century epic *The Dream of the Red Chamber* (*Hong Lou Meng*) by Cao Xueqin is frequently hailed as the greatest work of prose in China's literary tradition. The 120 chapters of *Dream* have been discussed and studied by devoted scholars to such a degree that it has produced a scholastic genre called "redology" (the study of *The Dream of the Red Chamber*). After more than 200 years of debate, scholarly attention is still unevenly divided as to what this profound story is "really" about, but fervent interest and love of this novel have not waned.

The first five-chapter section of *The Dream of the Red Chamber* is a mythical story within a story that serves as the thematic nexus of the novel. *Story of the Stone* retells this tale. At the outset, a simple stone is imbued with divine intelligence and longs to experience the life of man in the land of the Red Dust (Earth). Vermilion Pearl, a delicate red flower, accompanies the Stone to Red Dust, with a pledge to repay the Stone's kindness to her with "as many tears as can be shed in a lifetime." Bao-yu, the novel's protagonist, is the Stone reincarnated. He is born with a beautiful jade in his mouth and, though no one knows why, they take the stone as a sign that he is special. Indeed, he is very different. A wild and difficult child, Bao-yu refuses to play with other boys and is drawn to feminine things. Because of Bao-yu's nature, his doting grandmother raises him in the girls' quarters, among his female cousins. When cousin Lin Dai-yu, the earthly embodiment of the red flower, comes to live at

these quarters, the two are immediately attracted to each other by a mutual feeling of a shared past. Together they are pampered and spoiled, spending their days in the magnificent Grand View Garden. This garden is splendid like no other—a bit of heaven on earth and a poetic stage for the dramatic love tragedy that unfolds between the flower and stone over the course of the novel.

In old China, "red chamber" (or *hong lou*) referred to the opulent living quarters of wealthy men's daughters. Later it became synonymous with the daughters themselves. At the end of the fifth chapter, as if to signal the passing of his childhood, Bao-yu dreams of an encounter with the Goddess of Disenchantment. She teaches him the ways of love and presents him with a twelve-part song and dance entitled "Dream of the Red Chamber." The song foretells events from the lives of twelve young women who come to play important roles in Bao-yu's life, though, at the time, its meaning escapes him. Through the melancholy poetry of the songs, the author offers us a glimpse into the love triangle ahead and introduces us to fragile lives bound by the social restraints of the late Ch'ing dynasty. This chapter also acts as a thematic bridge to the saga of a noble Chinese family in decline that transpires over the book's remaining 115 chapters. Two families and several generations live in a palace of pretenses, struggling under the weight of mismanagement, lost fortunes, and changing times. Woven into this tapestry are over 500 portraits of characters so deftly portrayed we cannot fail to recognize ourselves in them.

Although *The Dream of Red Chamber* has been translated into English, it is difficult for Western readers to grasp the full beauty of the work. As Lao-tzu said, "The Tao that can be spoken is not the eternal Tao." Nuances of meaning can be lost in the conveyance of ideas from one language to another. I created the images in *Story of the Stone* hoping to illuminate for the Western mind the magnificence of Cao Xueqin's masterwork in a way that English translations have not.

My text is not a literal translation but a personal interpretation taken from English volumes I have studied and interviews I have conducted with scholars and redologists in China. I am fortunate to have obtained permission from Yang Xian-yi and Gladys Yang to incorporate their translations of prose and poetry (except where noted) into my text.

Certainly the genius of *The Dream of the Red Chamber* lies in its universal appeal. While scholars continue to study the infinite details of Cao Xueqin's life,

his calligraphy, the structural aspects of his manuscript and its literary merit, and his meticulous detailing of Chinese social customs, culture, and thought— most people simply find delight in the love story it portrays. I myself was as fascinated with the degree of passion associated with the story as I was with the story itself. We say one can experience an epiphany through art that achieves such a level of perfection that it reveals the hand of the divine. So it seems with *Dream*. We relate to a truth that transcends time, place, and cultural boundaries. The artist, in being true to his artistic vision, opens a window through which we may glimpse our own truths—each of us from our own perspective. The author's creative exuberance, so evident in his work, moved me to create this labor of love. *Story of the Stone* is my tribute to a master artist. While I took some creative license, I tried to remain true to the text within the best of my ability. I hope it conveys the essence of the story and entices readers to explore further.

LINDA CHING

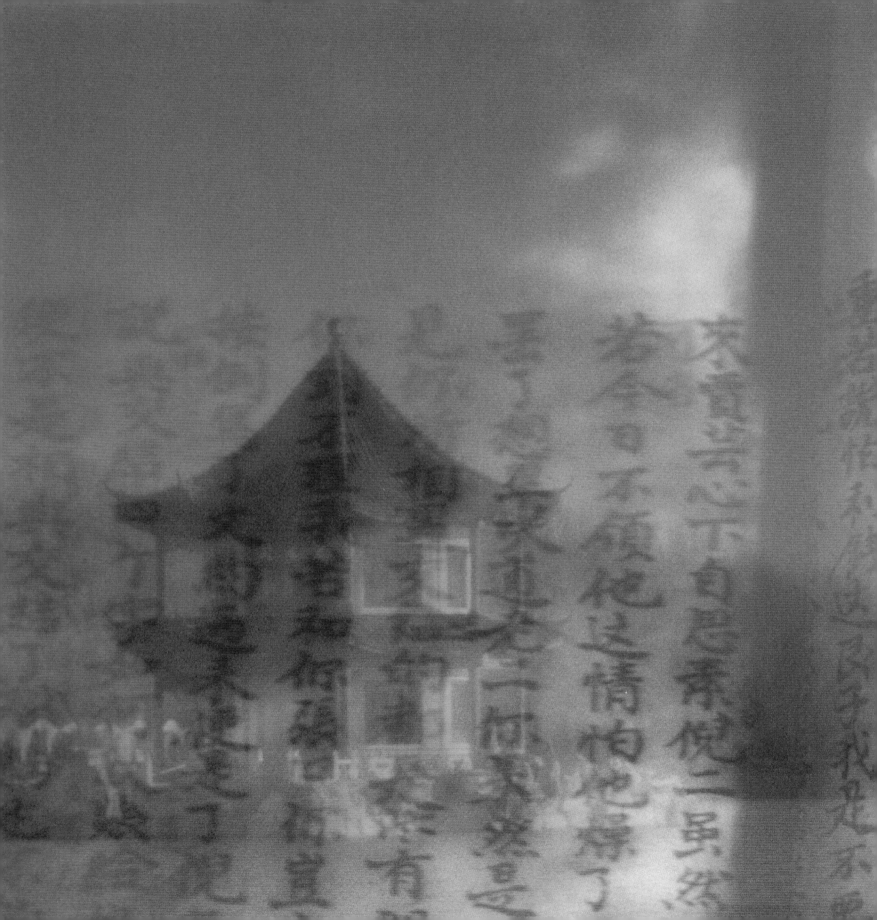

Reflections of the Dreamer

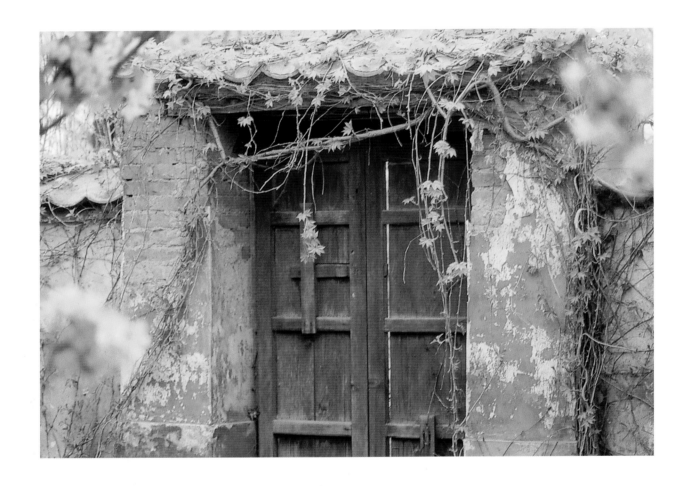

ao Xueqin—The magnificent dreamer. Very little is known about the author's life though his novel, *Dream of the Red Chamber*, gives us insight into the mind and soul of this man of uncommon talent. The rich legacy he left behind has nurtured dreams and inspired followers spanning the last two centuries. His life and his life's work is intriguing for they artfully intertwine illusion, reality, dream and mystery.

The details of Xueqin's early life is sketchy at best, yet much has been speculated about his life and his ancestors. His singular literary accomplishment has inspired movies, books, papers, musicals, Chinese operas and at least one television series over twenty hours long. These can be found in such abundance that, even for serious students, it is difficult to separate fact from fiction.

Pages full of fantastic talk
Penned with bitter tears;
All men call the author mad,
None his message hears.

RIGHT:
Manuscript,
Dream of the Red Chamber

寫正文筋

看官当用

眼不為破

壬午季春
过方好

中贫富不一或性情参商所謂源遠水則汚枝繁則
為子孫諜千年業者痛

有那家業艱難安分的　即令秦氏之喪族中諸人皆權在鉄檻寺
妖右艱難就安分矣便住在
寫貴則不安分矣

的只說這里不方便一定另外或村庄或尼庵寻

便不用說阿鳳之心因而早遠人来和饅頭庵的姑子浄虚
喜見祖宗體面賈珍一刻的

于来作不虛原来這饅頭庵就是水月寺因他庙

渾號離鉄艦寺不遠兩人詩云縱有千年鉄門限終

完奠過晩賈珍便命賈蓉請鳳姐歇息鳳姐見還

已便辞了尼姑往水月庵来春纂

智能兒越發長高了模樣兒越發出息了且說逆

不往我們那里去净虚道可是這几天都沒工夫

太送了十兩銀子来這里叫諸几位師父念三日

来請奶々的安虛隂一個胡姓以言

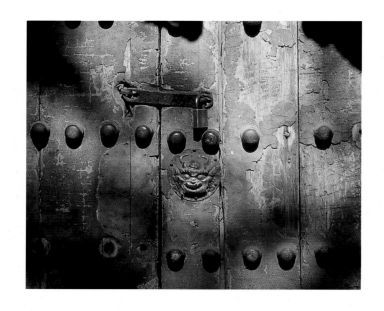

Central to the intrigue of *Dream of the Red Chamber* is the "missing" last chapters of the book. After Xueqin died in 1763, copies of the first eighty chapters were passed around elite circles and friends. Soon copies found their way into city bookstalls and markets. Its popularity grew. Then, in 1791, the first printed edition appeared with the last forty chapters "filled in" and "edited" by a gentleman named Gao E. This version became so well known that, for a while, many people believed Gao E was the true author and Cao Xueqin's identity was buried and forgotten. The last forty chapters satisfied the public's thirst for an ending but these chapters have been strongly discounted for their lack of literary style and grace.

We do know that Xueqin's family enjoyed a life of privilege and stature until a series of reversals reduced them to a life of poverty. Xueqin would have been about 13 years old at the time of his family's fall—just the age of Bao-yu, the novel's protagonist, through a greater part of the story. The author spent his last years living a modest life in the Western Hills of Peking. Here he penned his story

seemingly for his enjoyment and without the intent of publication. In this translation by Yang Xian-Yi and Gladys Yang, the author offered his reflections on whom he was writing about and what events inspired him:

"In this busy, dusty world, having accomplished nothing, I suddenly recalled all the girls I had known, considering each in turn, and it dawned on me that all of them surpassed me in behavior and understanding; that I, shameful to say, for all my masculine dignity, fell short of the gentler sex. But since this could never be remedied, it was no use regretting it. There was really nothing to be done.

"I decided then to make known to all how I, though dressed in silks and delicately nurtured thanks to the Imperial favor and my ancestors' virtue, had nevertheless ignored the kindly guidance of my elders as well as the good advice of teachers and friends, with the result that I had wasted half my life and not acquired a single skill. But no matter how unforgivable my crimes, I must not let all the lovely girls I have known pass into oblivion through my wickedness or my desire to hide my shortcomings."

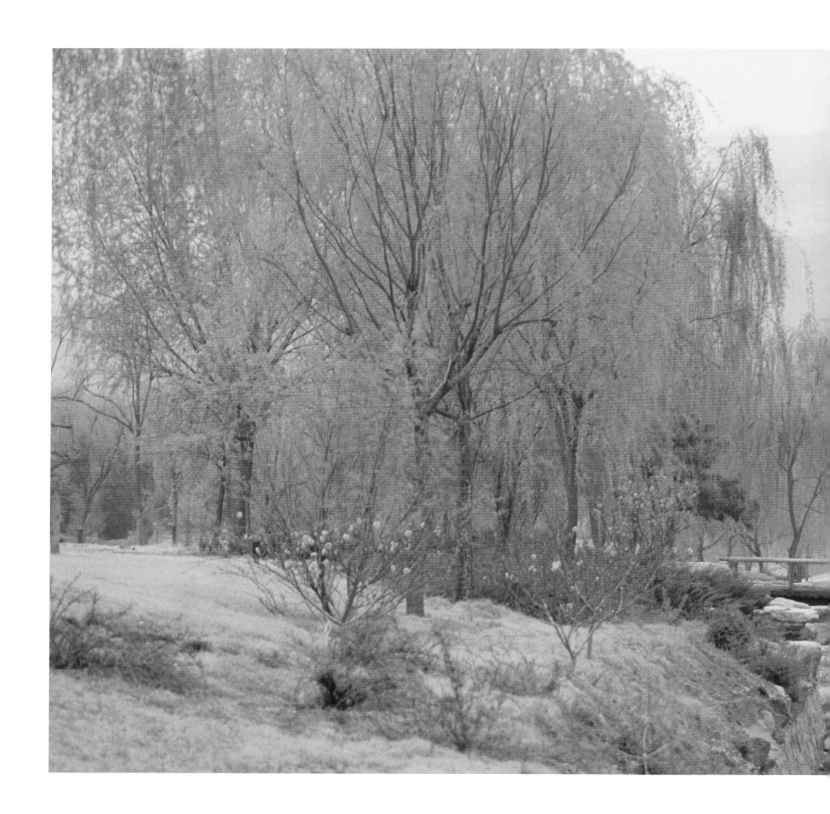

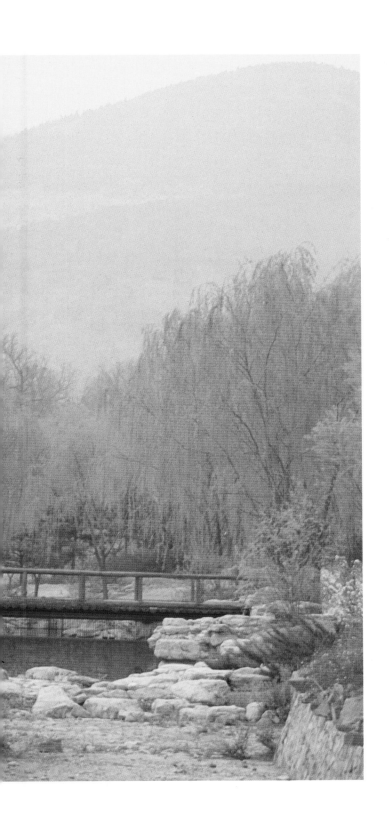

"Though my home is now a thatched cottage with matting windows, earthen stove and rope-bed, this shall not stop me from laying bare my heart. Indeed, the morning breeze, the dew of night, the willow by my steps and the flowers in my courtyard inspire me to wield my brush."

Cao Xueqin
translated by Yang Xian-yi
and Gladys Yang

RIGHT:
A home in Fragrant Hills, Beijing

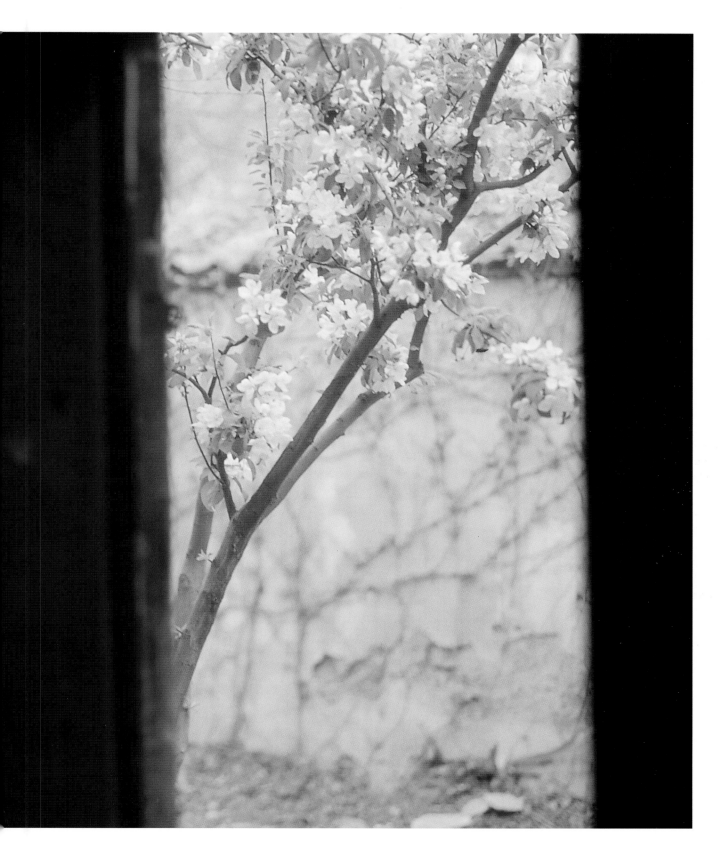

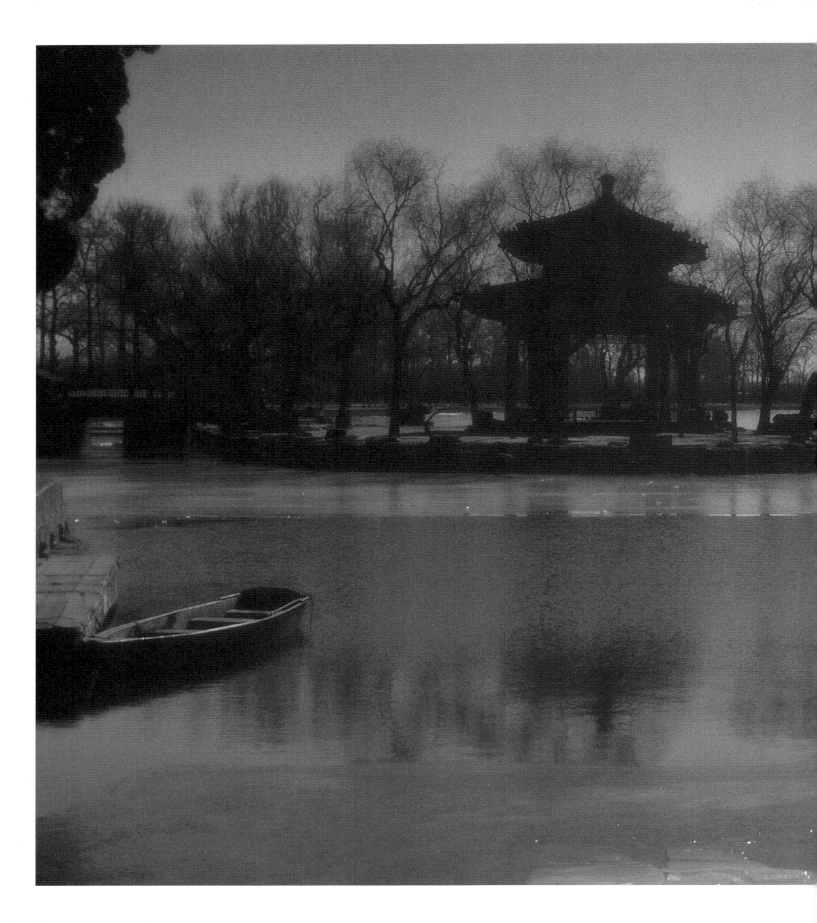

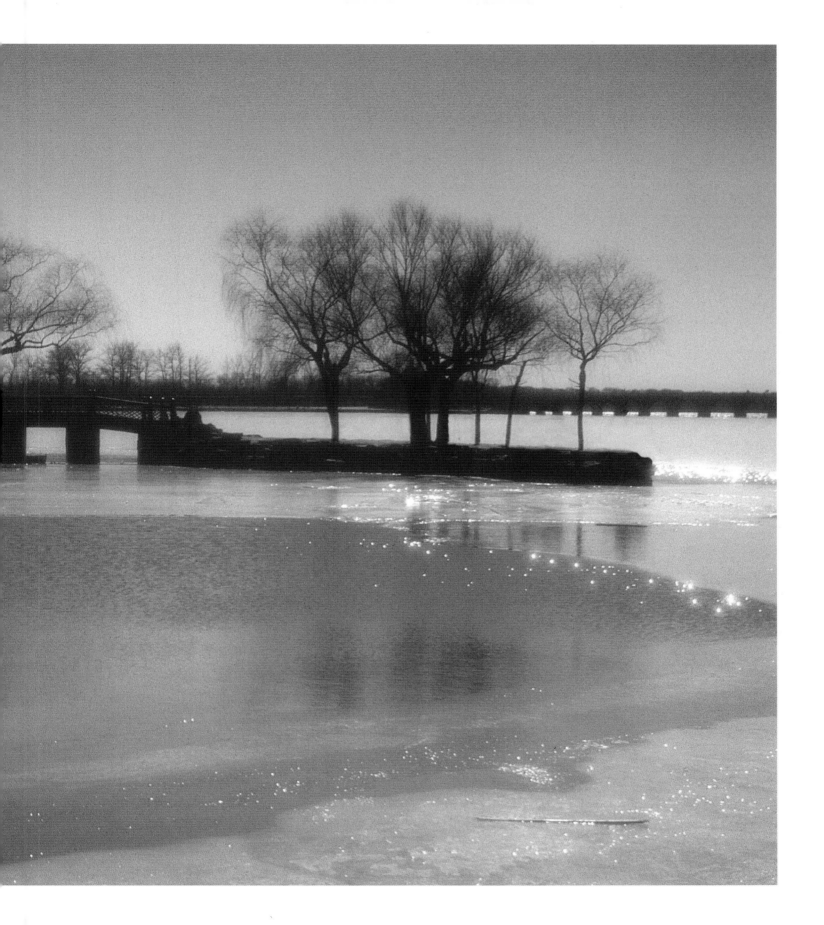

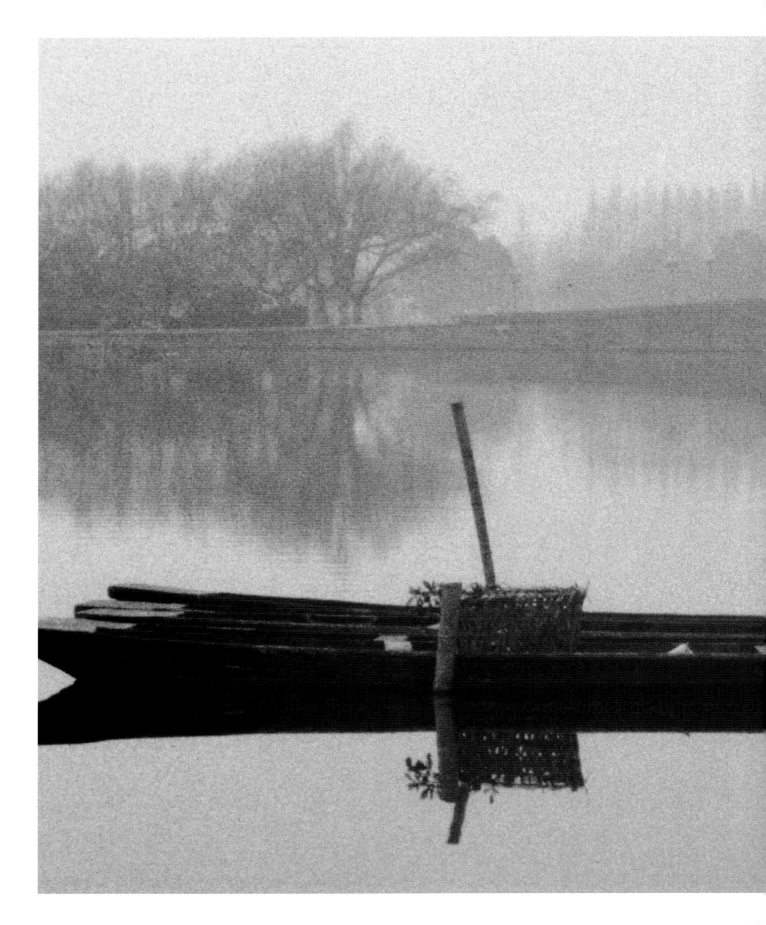

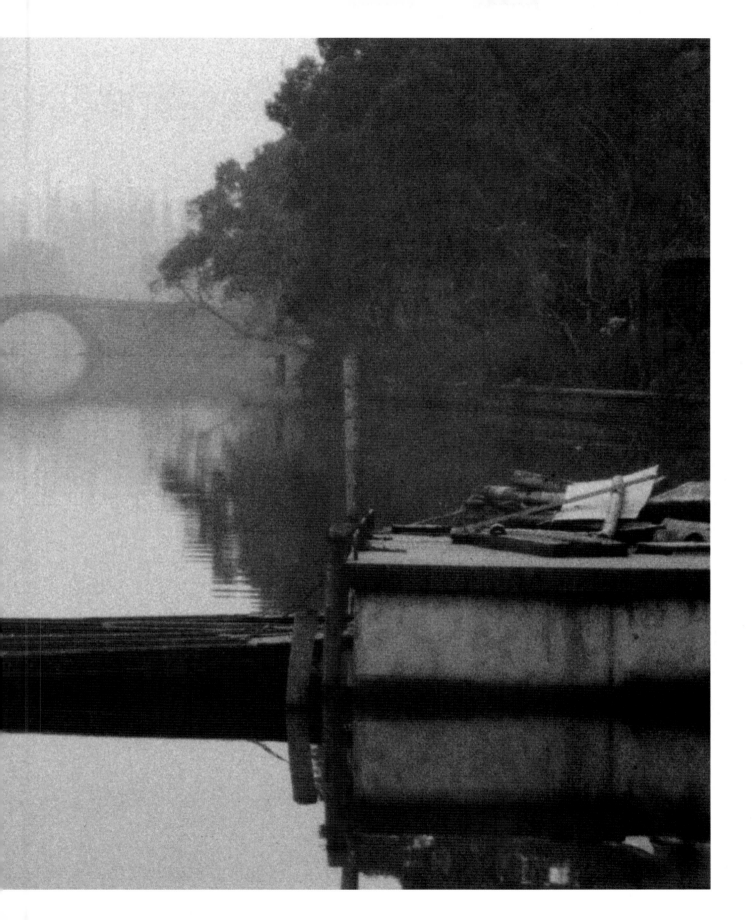

Mean huts and empty halls
Where emblems of nobility once hung;
Dead weeds and withered trees,
Where men have once danced and sung.

RIGHT:
Winter tree, Forbidden City
FOLLOWING PAGE:
*Vermilion Pearl and
the Divine Stone*

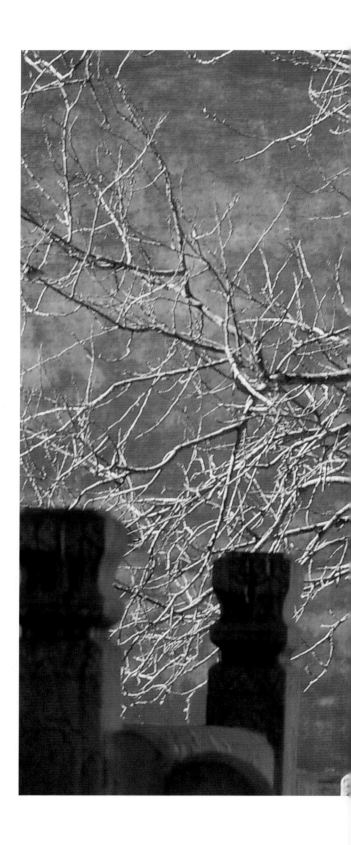

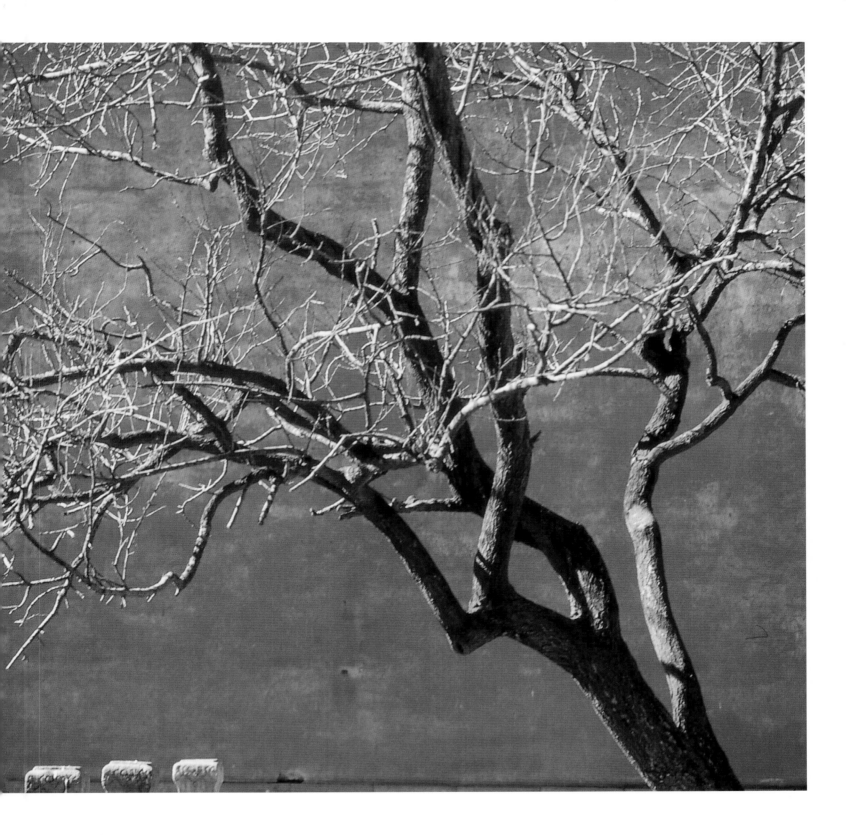

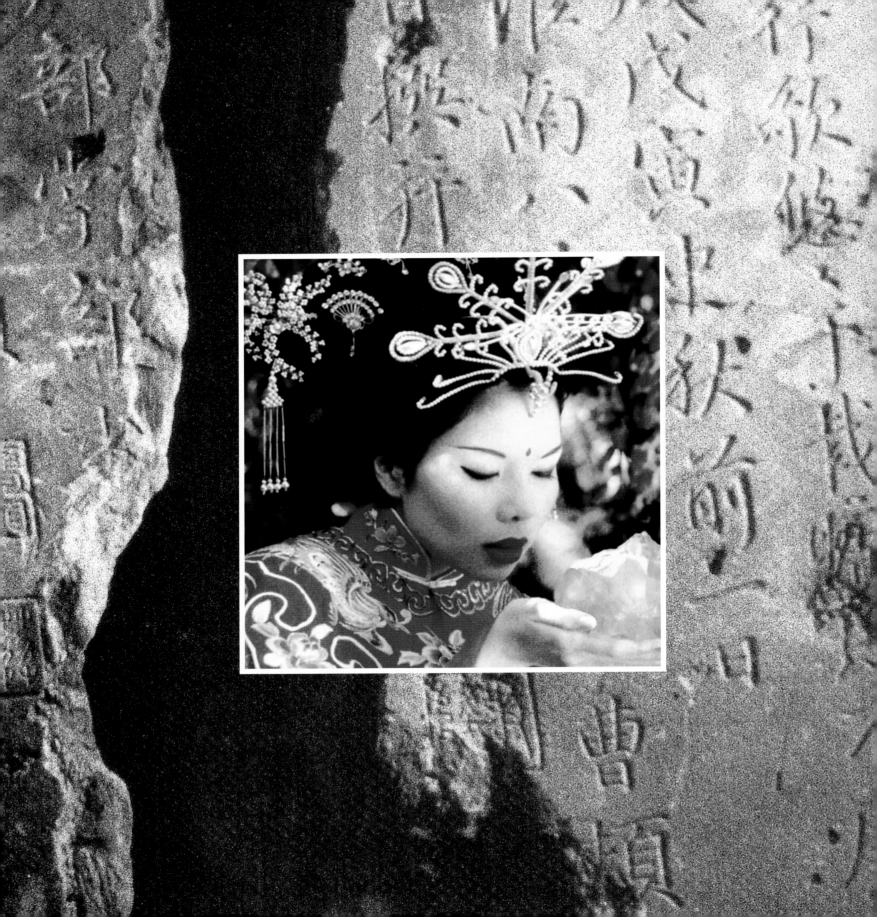

Story of the Stone

———

Unfit to repair the azure sky,
I passed some years on earth to no avail;
My life in both worlds is recorded here;
Whom can I ask to pass on this romantic tale?

No one knows if the Stone's story is true. Two hundred years of passionate debates and scholars still can't agree on what is true and what is not. They say the story was recorded in the Illusory Land of the Great Void like a divine imprint of the Stone's soul cast upon the Mountain of Expanding Spring. In time, the story came to the mortal Land of the Red Dust through enlightened daydreams of a Chinese poet living simply in the fragrant Western Hills of Beijing. It would take a man with a true and understanding heart to translate the Stone's story for mortal musing and Cao Xueqin was such a man. As the epic revealed itself to him, he faithfully recorded it with great attention to detail. From his Studio of Red Mourning, he would find the words like cryptic notes hiding in the face of a frosty China jade moon or catch them drifting on the reverie of summer's golden clouds. So sorrowfully like his own life, this tale, it is said he penned the characters in a hundred thousand tears.

Perhaps, not even the poet knew if the Stone's story was fact or fiction but with the endurance of time, we recognize the essence of the Stone's tale resonates with Truth. Cao Xueqin reminds us, after all,

"Truth becomes fiction
when the fiction's true.
Real becomes not real
when unreal's real."

I too have dreamt the story of the Stone. In search of greater understanding of this dream I traveled to the center of Cao's world and found that I was only one of many on the same quest. One of the titles Cao considered for his story was Fengyue Baojian (A Mirror for the Romantic). Did he know that our own truths would be reflected in the revelation of his day-dreams? How true it seems that a memory of the Stone's story is indelibly imprinted upon our souls.

According to Cao Xueqin, this is where the Divine Stone's journey began.

The eternal way of the water tore a hole in the Celestial Dome and flooded the mortal land of the Red Dust. Goddess Nu Wa took to repairing the heavens with melded blocks of stone which she collected from the Baseless Cliff of Great Waste Mountain. The ancients recorded that Nu Wa gathered 36,501 blocks of stone for this task that were 120 feet high and 243 feet square. She used all but one of these stones then discarded the leftover stone at the foot of Blue Ridge Peak at the Root of Love. The divine hand of the Goddess sparked life into this stone and imbued it with spiritual understanding and unusual mystical powers. It moved about at will, changed its size and shape and displayed an uncommon amount of intelligence. Instead of feeling joyful gratitude the Stone lamented. You see, this new understanding, had awakened feelings of shame for it alone had been cast unfit for Celestial repair. The Divine Stone felt useless.

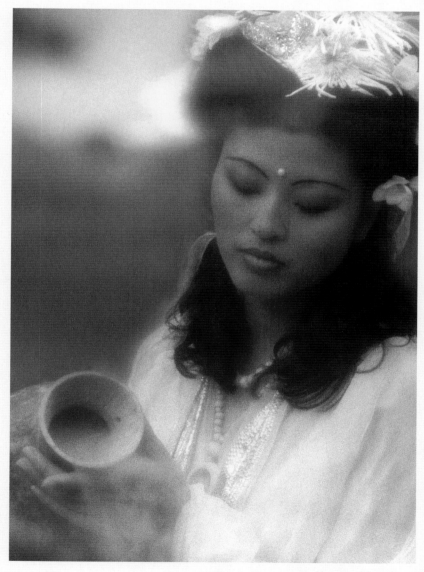

Goddess Nu Wa

*The eternal way of the water tore a hole
in the Celestial Dome and flooded the
mortal Land of the Red Dust.*

*One day as the Stone brooded over its tragic fate, the
Buddhist of Infinite Space and the Taoist of
Boundless Time appeared.*

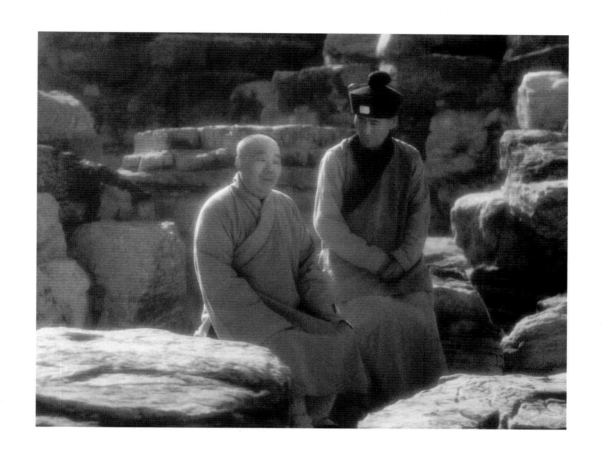

It came to be that the Stone's chief occupation was brooding over its tragic fate, sighing dejectedly as it roamed about. One day, as it was doing just that, the Buddhist of Infinite Space and the Taoist of Boundless Time appeared from a distance. The Stone observed the two engaged in lively conversation and noted that they were equally distinguished and rather remarkable in appearance. As it happened, the Divine Stone was also quite eye-catching in its present luminescent fan-pendant form. Not surprising then that the two would notice the Stone immediately when they sat down beside it for a rest. The Buddhist Monk picked up the stone and addressed it squarely in the palm of his hand, "Ah, I can see you are a precious object with magical properties but you have something lacking. I can remedy this by carving a few identifying characters on you so people will recognize at a glance that you are exquisitely special. Distinguishing features will elevate people's perception of you. Then we can take you to a prosperous cultivated realm where you can partake in the delirious pleasures of luxury. You will be able to settle down in comfort with a family of official status and enjoy the grace of flowers and arresting willows."

The Stone could not believe its change of for-tune. What words will you engrave upon me? Where do you intend to take me? Please enlighten me!"

The Monk laughed. "No questions. You will know soon enough." With that he tucked the Stone into his sleeve and hurried away to places unknown.

Time past unrecorded. No one knows how many generations went by before a Taoist known as Reverend Void set out in search of the Way and the secret of immortality. He chanced upon a large engraved stone positioned on the Baseless Cliff at the foot of Blue Ridge Peak. The inscription on the stone was long and distinctive. Reverend Void inspected it with curiosity then read it through. The story upon the stone told of its humble beginnings as a lifeless block and how it had been found unworthy of repair-ing the sky. It recounted its magical transformation, how the Buddhist of Infinite Space and the Taoist of Boundless Time transported it to the world of mortals where it lived as a man of culture before finally attain-ing nirvana then returning to the other world. It detailed its experience of joys, disappointments, amorous encounters and daily domestic life. On the back of the stone was a Buddhist verse:

Unfit to measure the azure sky,
I passed some years on earth to no avail;
My life in both worlds is recorded here;
Whom can I ask to pass on this
romantic tale?

The name of the region of its incarnation followed but, curiously the country, dynasty and year were omitted. The Reverend Void knew he was in the presence of a being of eminent stature. As he concluded the text he addressed the Stone with all due respect, " Brother Stone, you seem to think your story merits publication. I do not think I can assist you with this. As far as I can see it will not inspire much interest even if I were to transcribe it in its entirety. In the first place there is no clue of the dynasty and year, secondly, it does not contain a message of public morality, no stories of grand and loyal ministers just a few girls who are not particularly talented or outstanding except for their passion and folly."

The Stone mocked good naturedly, "Oh, come now, eminent sir. How can you be so dense? You can easily ascribe my story to the Han or Tang Dynasty like all other romantic novels. But why stick to convention? Popular writers of the breeze and moonlight school corrupt minds with pornographic filth and moralistic stories of virtuous, talented stereotypical beauties can be found in countless thousands all following the same pattern. Rather than conforming to the artificial order of tra-

dition, I prefer my way. It is much more interesting and fresh to write of the lovely girls I have known and account my feelings and adventures truthfully, just the way it happened.

The daily concerns of the impoverished is food and clothing, while the wealthy are never satisfied with their accumulated riches. They are preoccupied with material acquisitions, lustful pursuits and other temptation. I only wish to provide a distraction for them at times when they are sated with food and wine and are in search of an escape from life' s worries. Perhaps, it will replace other vain pursuits and provide a distraction from chasing what is illusory. Will you be convinced?"

The Reverend Void was lost in contemplation. He could see the wisdom in the Stone's intention so he re-read *The Story of the Stone* this time in a different light. It is true, he thought, although the main theme is of love it is presented as a faithful detail of events. In this way it was indeed superior to other novels. Finding the story free of any kind of negative persuasion or intent he copied it from beginning to end and went on his way to find a publisher.

Reverend Void understood that all manifestations derives from nothingness and nothingness gives rise to passion, describing passion…He changed his name to the Passionate Monk and re-named the story to the *Record of the Passionate Monk*. Later Cao Xueqin labored over it for ten years and gave it a new title, *The Twelve Beauties of Jingling*. Today it is most popularly known as *Hong Lou Meng; Red Chamber Dream or Dream of the Red Chamber*.

That aside I can now tell you what was recorded on the Divine Stone.

RIGHT:
*The Reverend Void communes
with the Divine Stone*

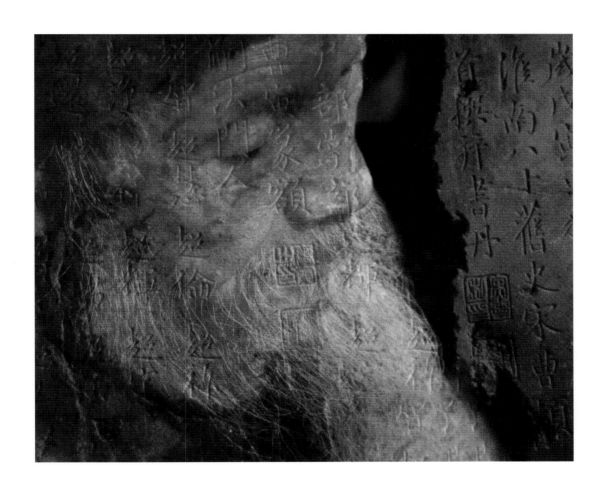

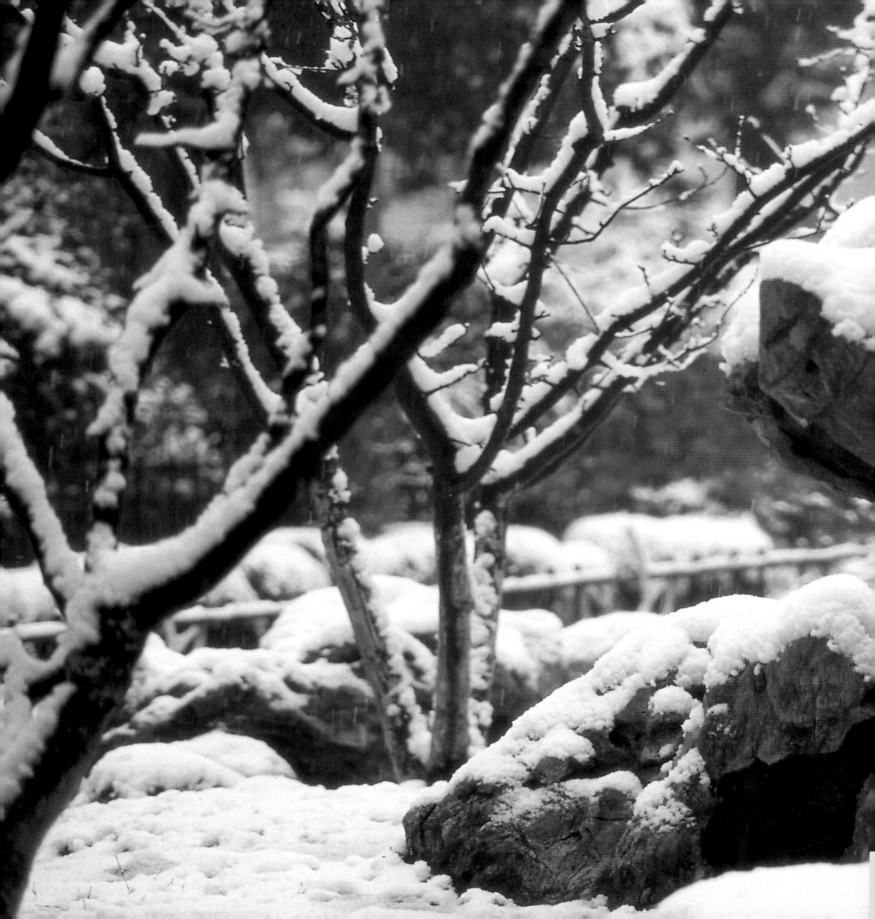

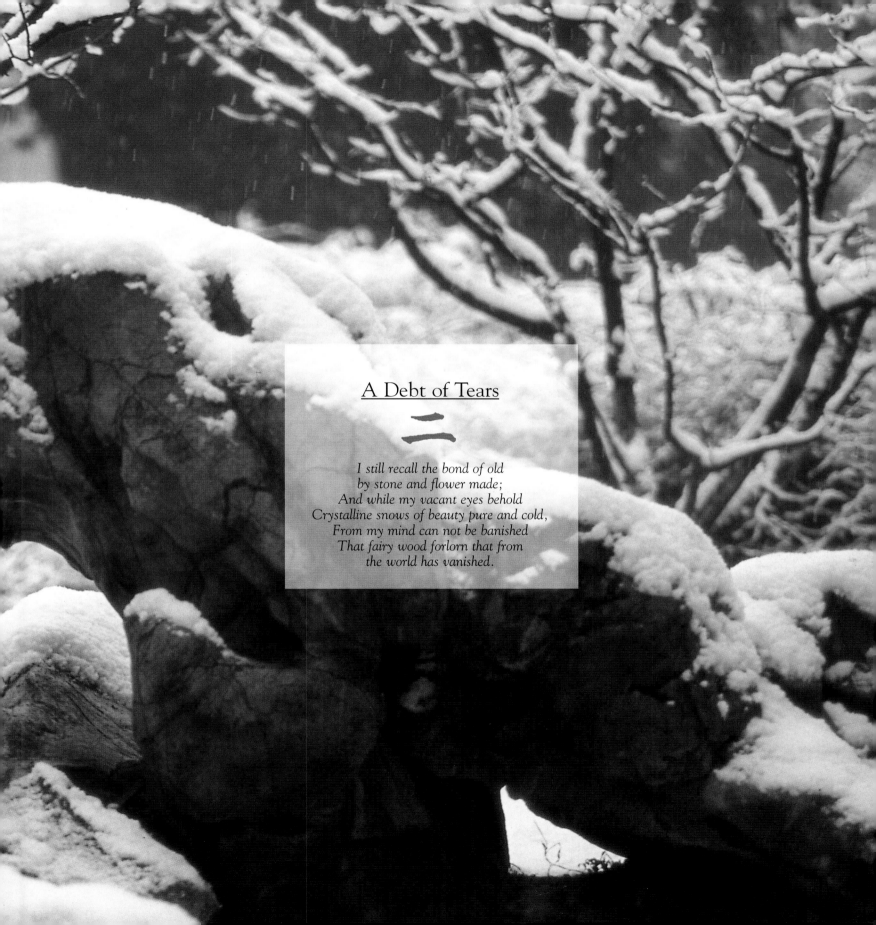

A Debt of Tears

I still recall the bond of old
by stone and flower made;
And while my vacant eyes behold
Crystalline snows of beauty pure and cold,
From my mind can not be banished
That fairy wood forlorn that from
the world has vanished.

*I*n ancient times the world dipped downwards towards a southeastern city named Kusu. Today we know this city as Soochow but during the time that I speak of, one of the most affluent cultural centres of the world flourished around the Chang-men Gate of Kusu. Just outside of Chang-men gate was Ten-li Street. If you followed this street until you reached a sliver of a path called the Lane of Humanity and Purity, you would discover an old temple built within the confines of a very limited space. Accordingly, it was named for its unusual narrow shape; Gourd Temple. Just beside the temple lived a couple highly regarded by all who knew of them. Chen Shi-yin and his wife, Feng-shi were neither of nobility or great wealth but they were looked up to for their high virtues and decency. Shi-yin did not care for rank or wealth, his life was spent much like an immortal tending to simple pleasures — growing bamboo, cultivating flowers, sipping wine or writing poetry. Contentment was his except for the fact that he was now over fifty and didn't have a son though he did have a three year old daughter who gave him much pleasure.

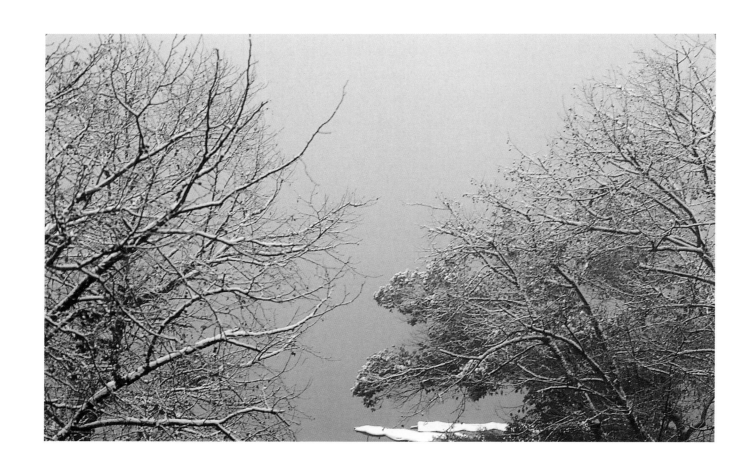

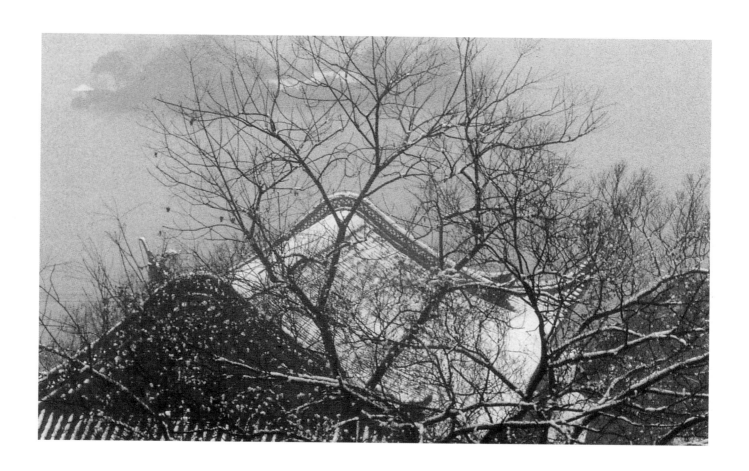

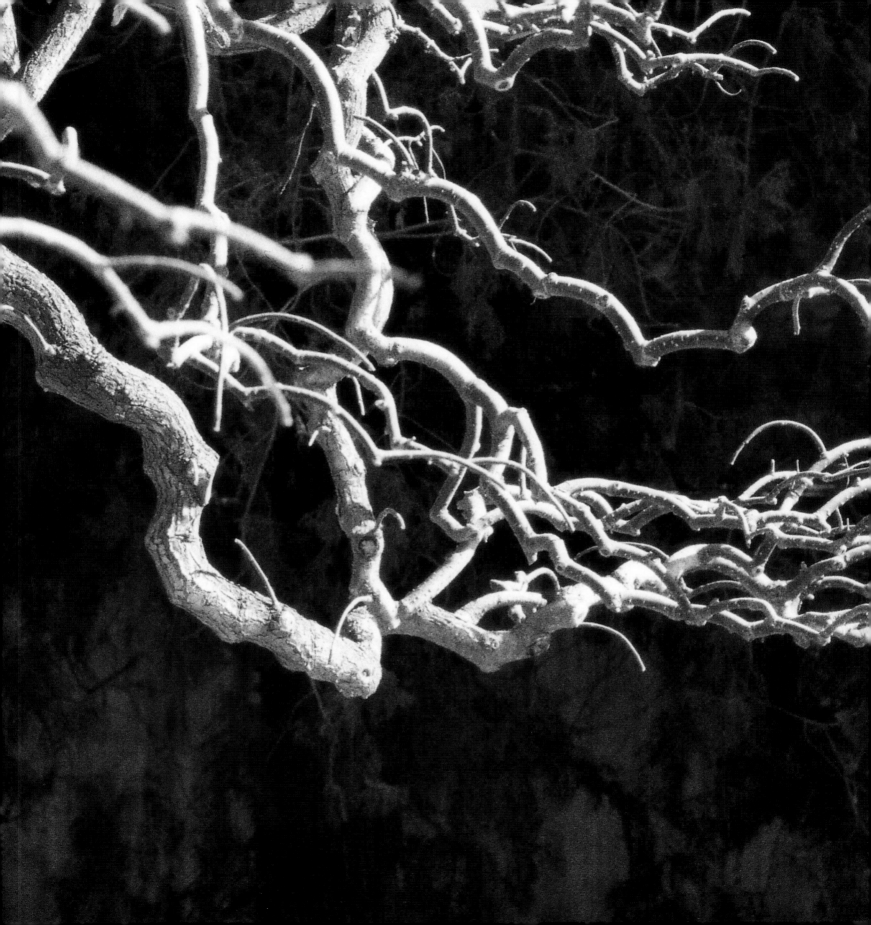

On a brutally sweltering summer day, Shi-yin's head dropped to his desk as he fell into a dream. In his dream state he traveled to an unknown place where he came upon a Buddhist monk and a Taoist engaged in a remarkable conversation.

The Taoist was asking the monk, "Where do you mean to take that stupid object?"

"Don't worry," replied the monk. "A love drama is about to be enacted but not all the players have yet incarnated. When the time is right, I will slip this foolish thing among them and give it the experience it wants."

"Well," mused the Taoist, "Yet another batch of amorous sinners insisting on making trouble by reincarnation. Where will this drama take place?"

"I'm sure you'll have a good laugh when I tell you this amusing story. I have never heard of anything like it. You'll remember that our friend the Stone took to wandering about after he had been discarded by the goddess. One day his wanderings brought him to the palace of the Goddess of Disenchantment. She recognized that he was truly special and thereupon bestowed him with the honorable name of Divine Stone of Luminescence. There on the bank of the Sacred River the Stone found Vermilion Pearl Plant growing beside the Rock of Three Incarnations. This frail flower became the object of his devotion. The Stone watered Vermilion Pearl daily with sweet dew and as the years went by this attentive nourishment fortified her heavenly essence and enabled her to blossom into human form, albeit only that of a girl. Instead of rejoicing in appreciation she roamed beyond the Sphere of Parting Sorrow feeding her hunger with the fruit of Secret Love and quenching her thirst at the Sea of Brimming Grief. You see, her heart was heavy for she had not been able to repay the Stone for the care he lavished on her. She drowned herself in sorrow and became increasingly obsessed with this unpaid debt.

Suddenly the Divine Stone was seized with longing to assume human form and experience the world of men, What better time for this, the Land of the Red Dust was enjoying a time of enlightenment and peace. He presented his request to the Goddess of Disenchantment who saw how this could be a delightful opportunity for Vermilion Pearl to repay her debt of gratitude. The Goddess also assembled other amorous spirits who had not atoned for their sins to take part in this great illusory drama.

Vermilion Pearl is determined to accompany the Stone to the Red Dust and pledged to repay him with as many tears as can be shed in a lifetime."

"You are right." said the Taoist agreeing with his comrade, "I have never heard of repaying a debt in tears. This love drama promises to be like no other. All other tales of breeze and moonlight never express true love and intimate details between young men and women. I'm sure when these spirits congregate in the Red Dust we'll see lovers and lechers, the worthy and scoundrels like we have never seen before. Why don't you and I join this little charade and try to save a few souls?"

"This is exactly what I was thinking. Today happens to be the day the Divine Stone is fated to be reborn so first we must take him to Disenchantment to clear all formalities. After the remaining souls descend to earth, we will follow. Half of them are there already."

Shi-yin had witnessed this entire scene entranced. Now his curiosity got the best of him and he stepped forward to make his presence known. With a respectful bow and a courteous smile he said, "Greetings immortal masters. It is rare for one such as I have to have the op-

portunity to listen in on a conversation regarding karma. I feel very priviledged but too simple minded to grasp the meaning of what I've just heard. If you would kindly enlighten me I promise to give you my utmost attention. The wisdom you impart may prove to be my salvation."

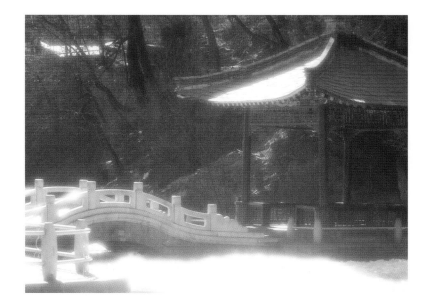

"We cannot divulge mysteries of the Heavens," they both smiled. "But you need only to think of us when the time comes and you may indeed escape the fiery pit."

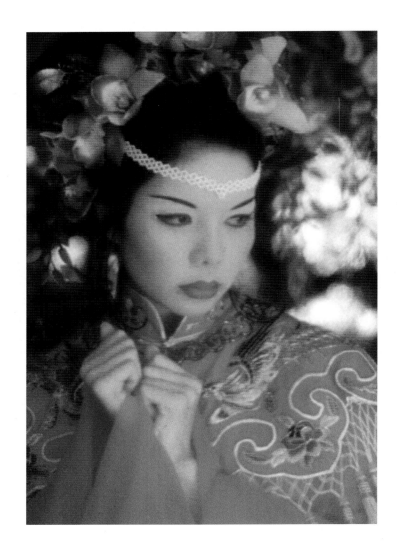

Vermilion Pearl pledged to repay
the Divine Stone for his kindness with
as many tears as can be shed in a lifetime.

"I understand the heavenly mysteries must not be revealed but pray tell me, what is the 'foolish object' you referred to?"

"If you want to know, I will tell you. As a matter of fact you are destined to encounter it in your lifetime." said the monk.

With that he pulled a beautiful translucent jade from his sleeve and handed it to Shi-yin. On one side was carved Precious Jade of Spiritual Understanding on the other side columns of smaller characters but before he could read the reverse side the monk snatched the stone away from him saying, "We have reached the Land of Illusion."

The monk and the Taoist passed through a large stone archway which read: Illusory Land of Great Void. Shi-yin started after them but heard a deafening crash. It was as though great mountains had collapsed causing the earth to quake from under. With a frightful cry Shi-yin awoke from his dream. The feverish summer blaze adding to his befuddlement. He shook himself as he regained consciousness, the dream already fading into shadows.

RIGHT:
The Buddhist of Infinite Space and the Taoist of Boundless Time enter the Land of Illusion.

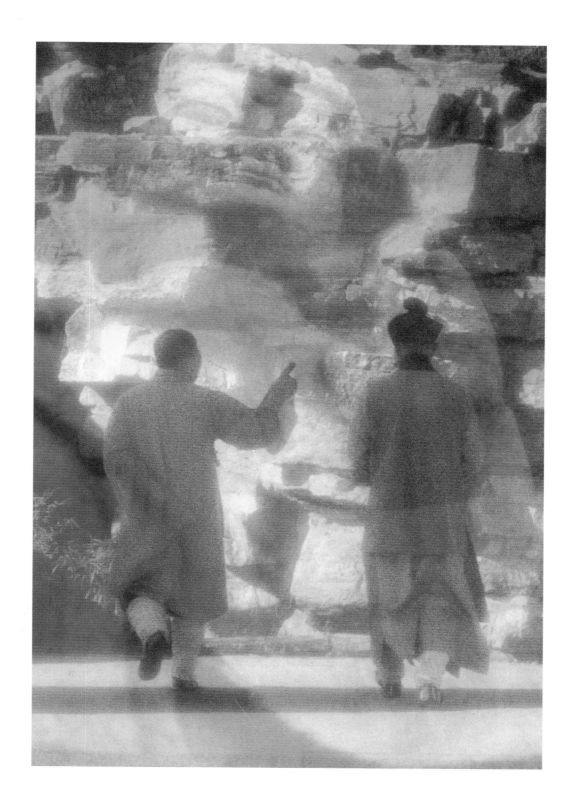

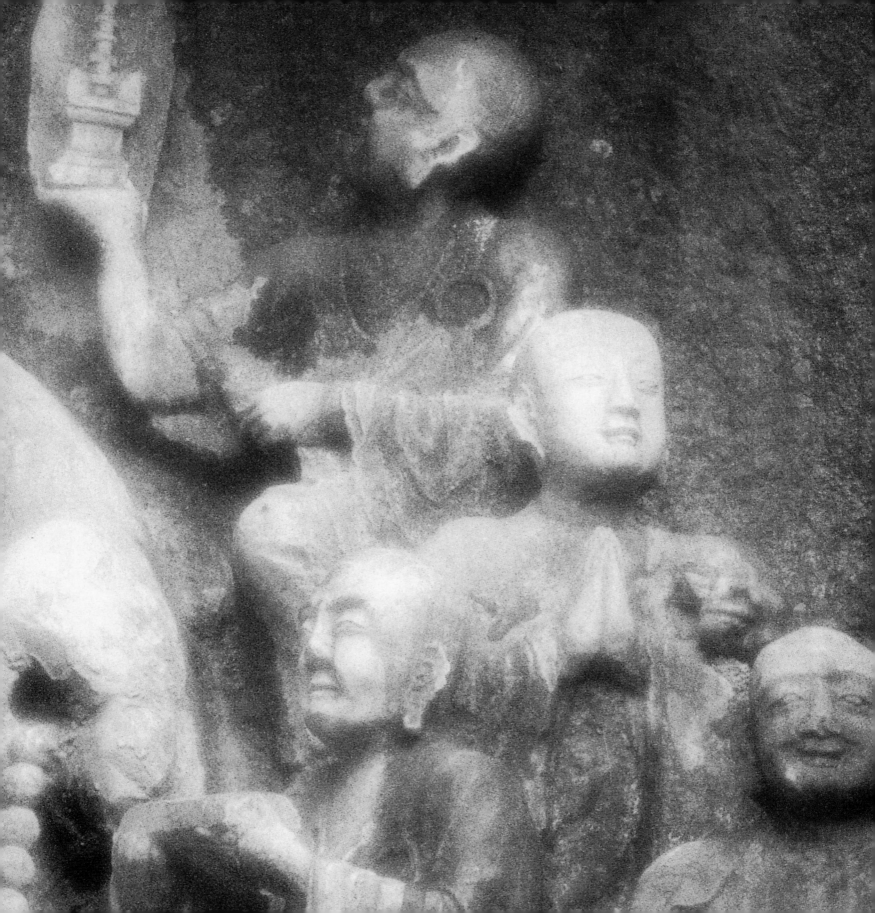

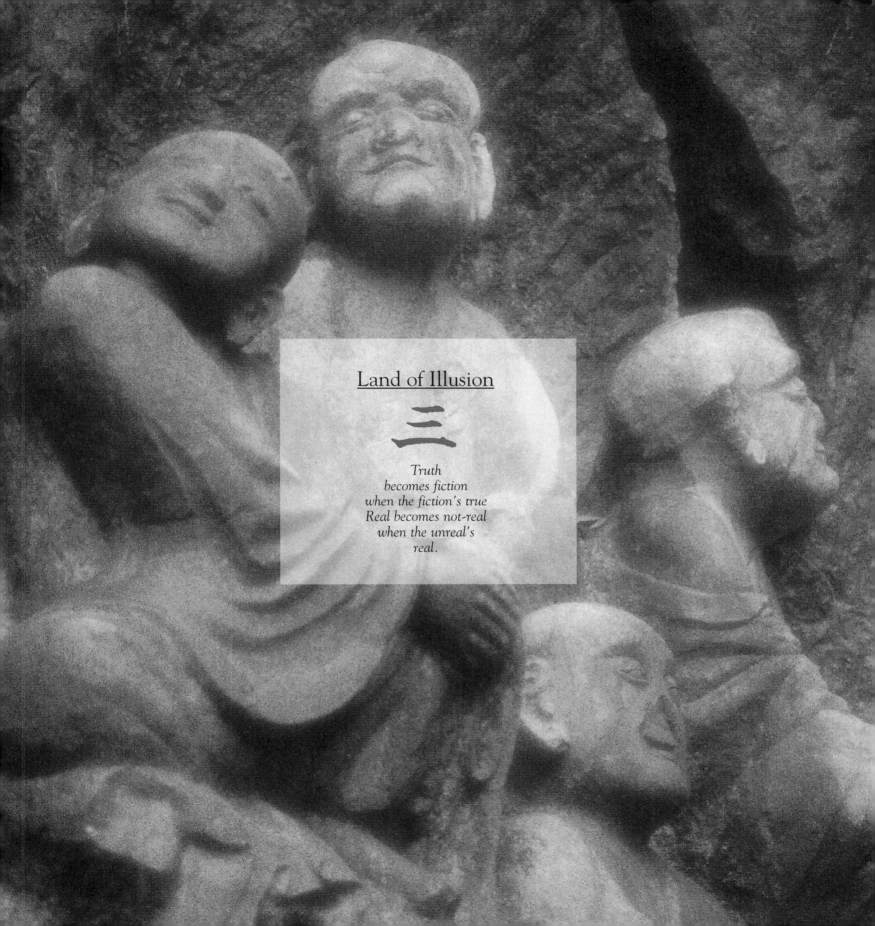

Land of Illusion

三

Truth
becomes fiction
when the fiction's true
Real becomes not-real
when the unreal's
real.

*S*hi-yin rubbed the sleep from his eyes and smiled at the sight of another heavenly creature before him. His little girl Ying-lian had been brought to his study by her nurse. Her presence gladdened his heart and filled his soul with pleasure. He reached out for her then held her dearly, "You grow more beautiful and lovable each time I see you." Then upon hearing the sounds of a ceremonial procession coming down the street, he brought Ying-lian out to the front gate to observe the excitement. For a while the spirited street scenes provided perfect afternoon amusement but now the crowd started breaking up. Shi-yin turned to leave but for no particular reason, he decided to stay a few minutes longer. A barefooted, disheveled monk and a mangy, lame Taoist priest advanced towards them, gesturing wildly and raving like a pair of lunatics. At the sight of the father and child, the monk lunged forward with wailing and lamentation, "Give me that ill fated child. Why do you bother with that poor creature? She will bring nothing but ill fortune to her parents! Give her to me!"

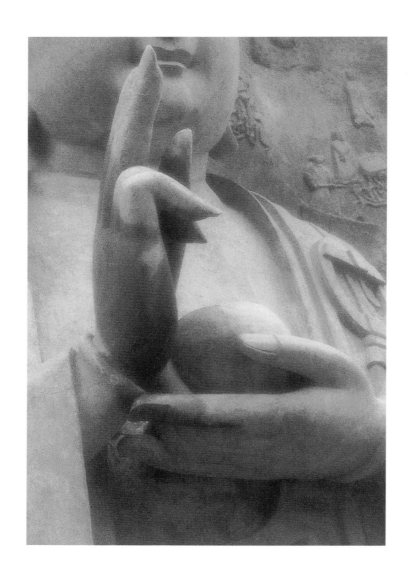

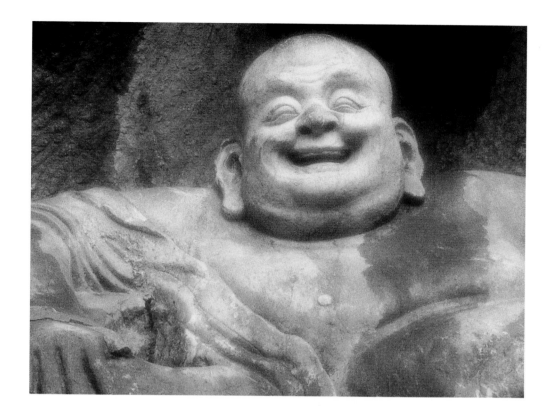

Shi-yin dismissed the mangy pair and started back into the house clutching Ying-lian safely in his arms. The monk carried on with insane howling then, pointing to the child, he proclaimed:

"Fool to care for this tender child:

An image in the mirror, snow melting away.

Beware what will follow the Lantern Feast,

The vanishing like smoke when the fire burns out."

Shi-yin wondered what these disturbing words meant but before he could ask he heard the Taoist say to the monk, "This is where we go on our separate ways. Let each attend his own business. Three aeons from now I shall wait for you at Mount Bei-mang, together we can return to the Land of Illusion to mark this affair off the register."

"Most excellent." agreed the monk.

Then they vanished like an evanescent dream.

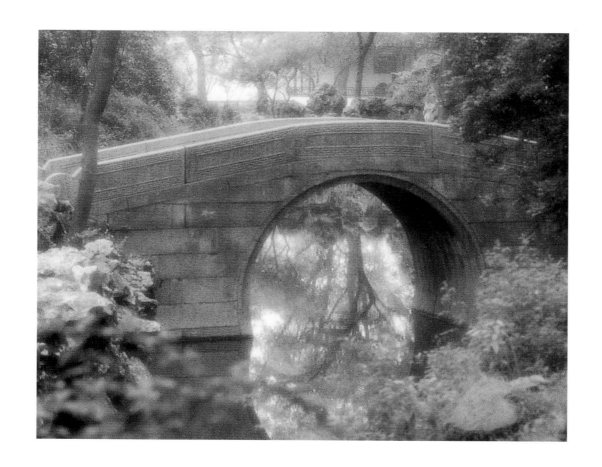

Certainly, these were no ordinary beings. Shi-yin was lost in contemplation regretting that he lost the opportunity to ask the monk what he meant. But his reflections were cut short by greetings from the poor scholar who lived at Gourd Temple. Yu-tsun was the last in the line of scholars and officials from Hu-zhou. The family wealth was lost about the time of his birth. Now he was alone in the world and had come to town in hopes of elevating his position. As luck would have it, this was not the case. Yu-tsun ran out of money quickly and was now working as a meager copyist at the temple next door. In time the two neighbors struck up a cordial relationship. Shi-yin sent his daughter off with the nurse and invited his neighbor in for tea. During this fateful visit Yu-tsun found himself momentarily alone when his host excused himself to attend to some business. Just outside the window he could see the house maid gathering flowers. Although not a great beauty, she had uncommon features with bright eyes and a lovely manner. Even better, Yu-tsun thought, she shows good judgment for twice she seemed unable to resist looking back at him to return an appreciative glance. So few had shown him attention in his obscurity much less any measure of admiration. He lost his heart as it fluttered about the Chinese garden. He went home that evening looking forward to the next opportunity when he could pay a visit.

The time came during the full moon of the Mid-Autumn Festival. Shi-yin had a table set in his study then took an evening stroll to Gourd Temple to invite his friend over.

On this evening Yu-tsun's infatuation inspired a moonstruck verse:

"Not yet divined the fate in store for me,
Good reason have I for anxiety,
And so my brows are knit despondently;
But she, as she went off looked back at me.
My shadow in the wind is all I see,
Will she by moonlight keep me company?
If sensibility were in its power
The moon should first light up
the fair one's bower."

Yu-tsun ran his fingers through his hair and sighed at the moon. It seemed useless to dream of the maid when he had so little to offer. He felt so far from realizing his ambitions he continued with this couplet:

"The jade in the box hopes
to fetch a good price.
the pin in the casket longs
to soar on high."

Shi-yin, who had just arrived overheard the verse, "Brother Yu-tsun! I see you have lofty ambitions."

Yu-tsun feeling a bit foolish, tried to recover by saying, "Not in the least. I don't have grand aspirations at all. I was just reciting lines I've memorized by an old poet. What do I owe the pleasure of this visit?"

"Well, you know tonight is the mid-autumn Festival of Reunion. I thought perhaps you might be in the mood for some camaraderie. I've prepared a little wine in my humble study. Will you share it with me?"

Yu-tsun needed little encouragement. "You are much too kind. I can't think of anything I would enjoy more."

The two men began the evening with tea and delicacies then indulged on a selection of choice wines. Soon they were drunk under the splendor of the new moon, singing voices from neighboring homes sailed with the evening breeze and blended enchantingly with flutes and strings raising from other homes. Under the influence Yu-tsun toasted the moon with another verse, so beautifully composed, his companion was moved to comment, "I've always known that you are destined for greater things. Your lines foretell a time you will ascend with the clouds."

Yu-tsun filled another cup and leaned toward his friend, "Don't think this is the wine boasting but I have no doubt that I could pass the city examinations and find a high post for myself but I am a struggling scrivener. With my meager wages I'll never be able to raise enough money for traveling expenses to the capital..."

"Is that what is stopping you? Why didn't you say so earlier? I have often wondered but did not want to risk offending you by bringing up the subject. I would consider it a privilege to take care of your expenses to the capital. Your luck is with you, the Metropolitan Examinations are coming up soon. If you move quickly you could get there in no time, you will be able to prove yourself by the Spring Test."

With that Shi-yin sent his boy to put together fifty teals of silver and two suits of winter clothes. Checking the almanac he determined that the nineteenth of the month would be a lucky day for traveling and suggested that a boat be taken for the journey westward. It gave him pleasure to think that by next winter they might meet again with success in hand.

Yu-tsun, accepted the silver and clothes in a rather off handed manner saying not much more then perfunctory words of thanks. He continued drinking and talking as though nothing much had been said. It was well after midnight when the two parted company. Shi-yin retired and didn't get out of bed until the sun was high in the sky. Recalling the offer he made the prior evening, he decided to compose two letters of introduction to city officials who might be willing to provide Yu-tsun with accommodations. However, when he sent his servant to deliver these letters, he found that Yu-tsun had left for the capital about five o'clock that morning. A message was left for him with the temple monk saying, "Scholars do not refer to superstitious "lucky days" for traveling but like to act according to reason. There was no time to say good-bye."

Shi-yin thought there was not much more he could do but be accepting. He shrugged and went on with his business.

The days passed uneventfully but soon it was time to celebrate the Festival of Lanterns. Shi-yin had his servant take little Ying-lian out to enjoy the fireworks and ornamental lanterns. The servant carried Ying-lian through bustling streets. As he wove his way through the merrymaking crowd he stopped to point out this pretty paper lantern and that one. Around about midnight, he put Ying-lian down on a door step then ducked around the corner to relieve himself. When he returned she had vanished. The servant panicked and searched through the night without success. As the sun rose the next morning, he knew he could not return home without severe consequences. Instead, he took to hiding in another county.

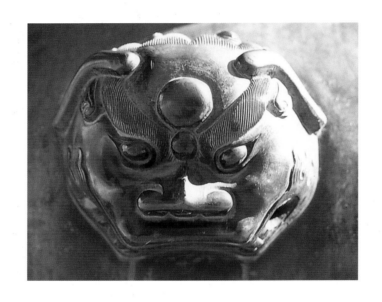

This tragic event took an emotional toll on Shih-yin and his wife. When search parties failed to find a trace of their precious, they lost their will to live and fell ill to grief. There was an eerie truth to the mad monk's prediction for this was only the beginning of the couple's woes, their lives were about to be irrevocably changed. On the fifteenth day of the third month, a fire swept through Gourd Temple devouring vulnerable bamboo buildings nearby. It then jumped from home to home until the whole area had the appearance of a mountain of fire. Shi-yin's house, being just next door to the temple was reduced to a mound of cinder and ashes.

The couple escaped with their lives and decided to move to their country farm but each year's harvest was either ruined by drought or flood. The countryside was terrorized by bandits who seized property and whatever else they could. The government troops hunting these peasant criminals caused nearly as much chaos. Under these impossible conditions, it was impossible to get ahead. Shi-yin mortgaged the land and fled seeking refuge with his father-in-law Feng Su.

Feng Su was not an honorable man nor was he pleased by the arrival of his daughter and son-in-law. He considered their stay an imposition and began to plot devious ways to trick Shi-yin out of whatever remaining money he had left.

The shock of this relentless series of misfortunes aged Shi-yin almost beyond recognition. He tried to find distraction one day by meandering down the street. As he hobbled along supporting himself shakily on a cane, he encountered a shabby chanting Taoist. After a brief exchange, he recognized that they were akin in their viewpoints of life. Without hesitation, he abandoned his former life and ran off with the eccentric Taoist.

This left Shi-yin's poor wife to live with her father without choice. She would do her best to contribute to household expenses by

doing a bit of sewing and embroidery with her two maids. A day came when the older of the two maids was at the front door purchasing silk thread just as the new mandarin passed the house borne on an offi cious sedan chair. She stared at him with surprise because his face was

so familiar. "Where have I seen him before?" she wondered. Then with out giving it any further thought she went back into the house. But this is not the end of this story for the new mandarin turned out to be our old friend, Yu-tsun. After Shi-yin had gifted him with the silver and

winter clothes he went off to examinations, then as predicted, did so well he became a Palace Graduate and given a provincial appointment. Now he had again been promoted to this new post. He had seen the maid purchasing thread at the door and, knowing her instantly, asked to take her for his wife. You see, she was the very maid who had looked back at him with interest in Kusu. Would you dream that one casual glance would have such an extraordinary outcome?

Yu-tsun was a talented and capable administrator but he was equally ruthless and extremely arrogant. In less then two years he was impeached. His dismissal, sanctioned by the Emperor, was cheered by his peers and co-workers. If this bothered him, you would not guess. He turned over his affairs without showing a bit of emotion. He neatly settled his wife and household in Hu-zhou and with that set off with his new found affluent freedom to tour the country and inspect the famed sight of the empire.

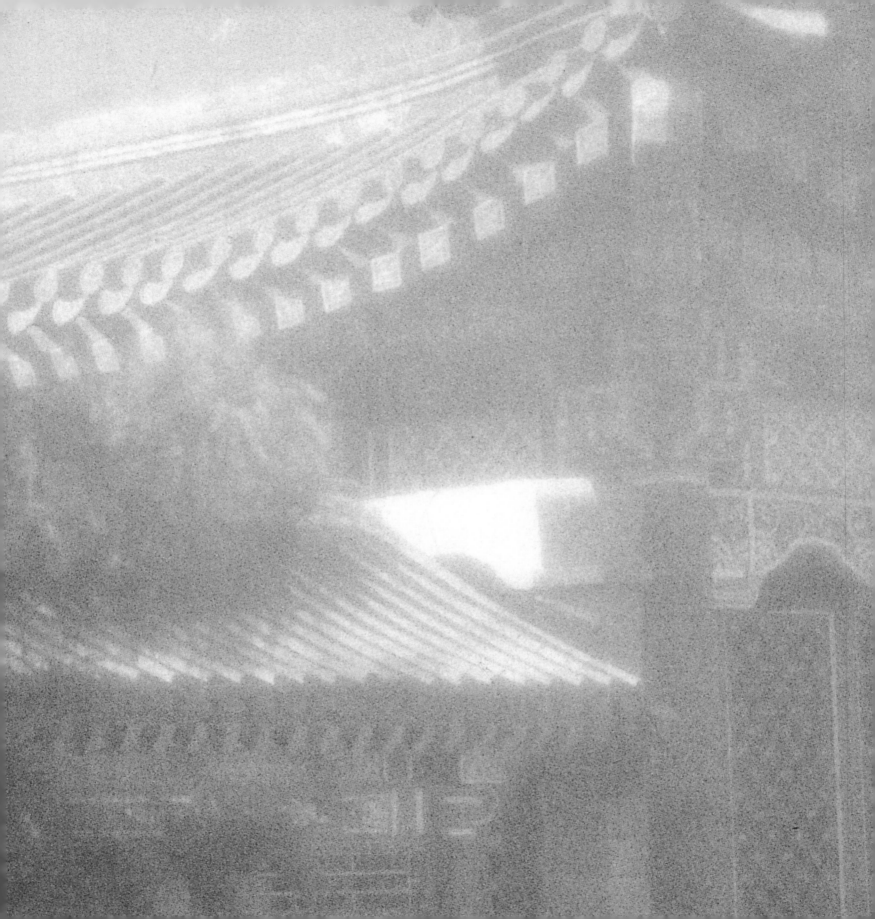

Dream of the Red Chamber

From drunken dreaming
one day you'll recover;
Then, when all debts are paid,
the play will be over.

*D*ai-yu sat on her bed tearfully regretting an unfortunate incident marking her arrival to Rong Mansion that day. An innocent remark she made threw the young master Bao-yu into a tantrum.

"Don't take it to heart, Miss Lin, said one of the attendants. "You mustn't let this bother you or you will be in tears constantly. I regret to say, you will witness even more absurd behavior from our young master in the days to come."

The welcome had indeed gone well. Just as her mother had described, the majesty of Rong Mansion was of rarefied proportions. It had been built by Imperial command and, appropriately, Dai-yu was treated with royal consideration.

"The sight of you breaks my heart,"
cried the Lady Dowager. "Of all my children
I loved your mother the best." It was
obvious from this first meeting that Dai-yu
would be favored dearly by her grandmother.
The Dowager's pet was the young grandson
Bao-yu (Magic Jade). Dai-yu heard stories
of how this special boy always wore
a bright, translucent jade around his neck,
which had been found in his mouth when he
was born. This was, in fact, the form taken
by the Divine Stone but no one in the
family, including Bao-yu, had a clue of its
origin. It was the size of a sparrow's egg,
iridescent as the clouds at sunrise and
inscribed with these seal characters:

Precious Jade of Spiritual Understanding
Never Lose, Never Forget
Eternal Life, Lasting Prosperity
On the reverse side it read:
Expels Evil Spirits
Cures Mysterious Diseases
Foretells Happiness and Misfortune

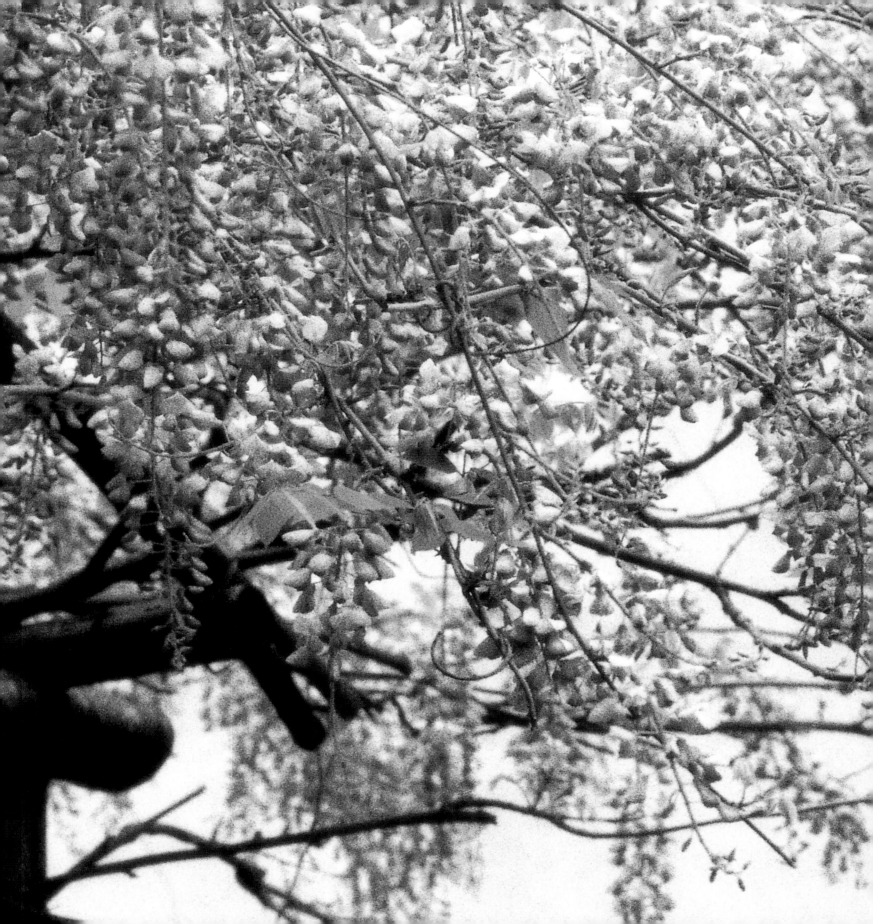

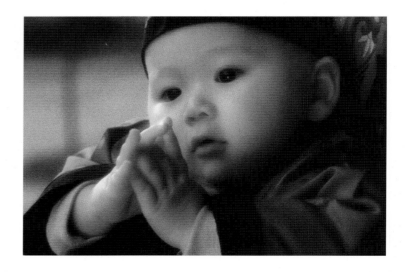

Dai-yu also knew her cousin was so doted upon by his grandmother that he was wild and uncontrollable. As customary in Chinese households, on his first birthday his father tested his disposition by setting a variety of objects before him and waited to see what he would select. The child ignored everything else and reached for the powder-box, rouge, and bangles. This decidedly put him out of his father's favor. It came to pass that the boy favored being with his female siblings and abhorred the boys for their filthiness. He was so adored by his grandmother for his pure intelligence and innate charm that she pampered him along with the girls of the house and allowed him to reside with them.

ABOVE:
The child ignored everything else and reached for the powder, rouge, and bangles. This decidedly put him out of his father's favor.

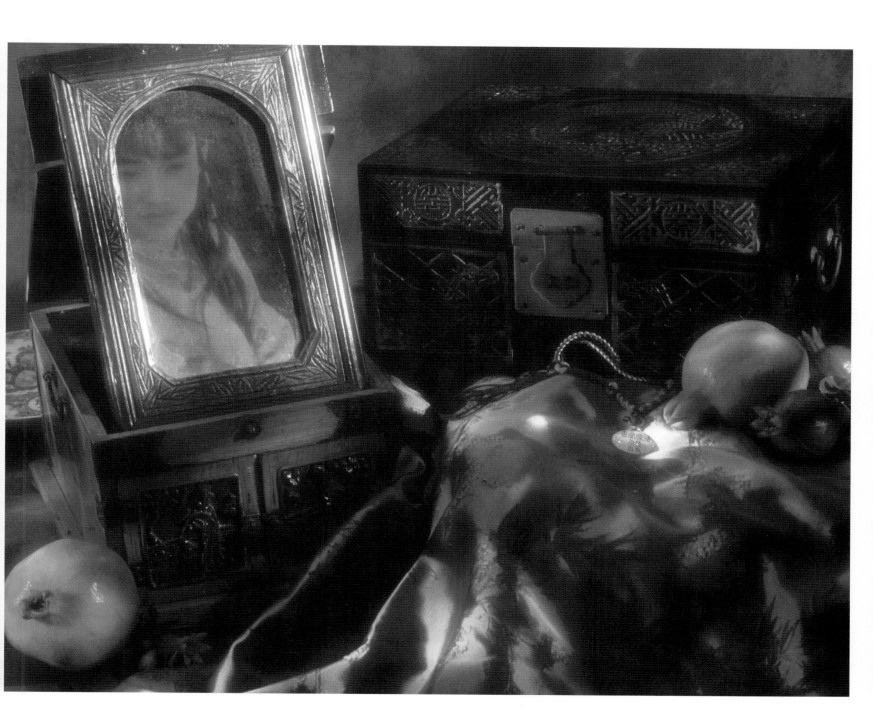

As soon as Lin Dai-yu was introduced at Rong Mansion, it was clear she would be dearly favored by her Grandmother. "The sight of you breaks my heart," cried the Dowager. "Of all my children I loved your mother the best."

RIGHT:
Lin Dai-yu arrives at Rong Mansion

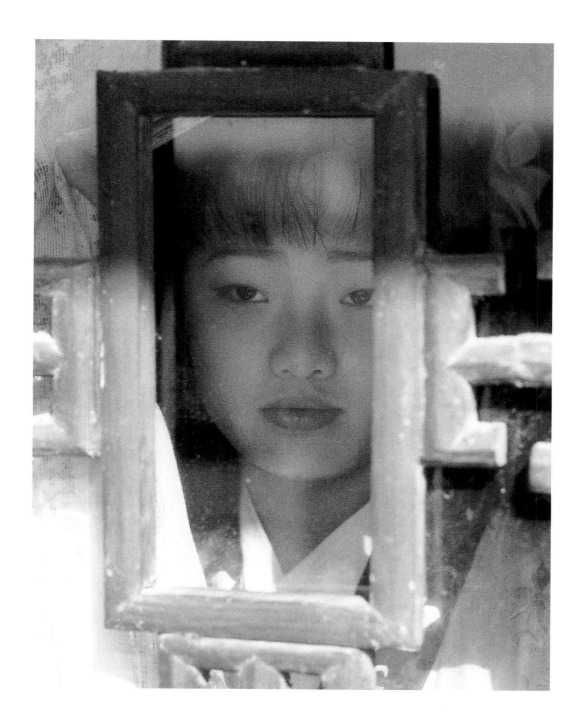

On the morning of her arrival Dai-yu was being presented to her elegant aunts and courtly cousins when a servant announced Bao-yu's entrance. Dai-yu felt a wave of reluctance to meet this infamous creature. She wondered what sort of graceless muck he might be.

To her amazement she found her cousin's face to be as radiant as the autumn moon. His lips were red as though glossed with rouge, his fair complexion so fine it could have been powdered and kissed by morning dew, his eyes sparkling with life and laughter.

Bao-yu was adorned with a golden bejeweled coronet and chaplet in the form of two dragons fighting for a pearl. His red archer's jacket was embellished with the finest embroidery and tied with a bright palace sash. Around his neck, hanging on a cord of five colors, was the much-talked-about, luminous jade.

Bao-yu's magnificent appearance caught Dai-yu by surprise but even more surprising was the familiarity she felt towards him. It was as if she had seen him before.

When they finally spoke, Bao-yu bowed and studied his cousin intently. "She is different from all other girls." He noticed how her eyebrows framed her face, knitted and yet not frowning. Her eyes revealed both gaiety and sorrow. Her frail beauty reminded him of a flower reflected in a pond and her movements of a pliant willow dancing in the breeze.

"I have met my cousin before," he finally declared.

"Nonsense," said his grandmother. "It is not possible."

"If I haven't, I still say I know her face. I feel this is like a reunion of two old friends after a long separation."

"Very well," laughed the Lady Dowager. "You are truly destined to become good friends."

It was then, after a few words of pleasantry, to the mystification of everyone in the room that Bao-yu asked Dai-yu if she had a jade. The girl, thinking he meant a special jade like his own, answered, "No, I imagine it is too rare for everyone to have one."

Bao-yu reacted in a wild frenzy. He tore his jade off his neck and threw it to the ground. Between sobs he cried, "This useless stone. What is so rare about it? What spiritual understanding does it possess? It's not fun that I'm the only one to have one!"

Grandmother Jia soothed the boy in her kindly way and the incident was put to rest. That evening, however, Dai-yu wept quietly over the incident. These were the first tears she would shed because of her cousin, but as the servant predicted, they would be far from the last.

With each passing day the pair grew closer. By day they played together and in the evening they slept in the same chamber. Bao-yu was still a silly, willful boy and sometimes just plain obtuse. Because he spent more time with Dai-yu than with anyone else, he would often offend her with his childish demands or thoughtless ways.

One day, they were going through another one of these tiffs. Dai-yu was in her room shedding hurt tears. She was feeling even more sensitive than usual. A new cousin had come to live at Rong Mansion. Bao-chai (Gold Hairpin) was just a little older but her refreshing, accommodating manner compared to Dai-yu's aloof reserve made her a new favorite around the household. Besides, Dai-yu thought Bao-chai received too much attention from Bao-yu and this made her feel jealous. Bao-yu now felt remorse for his tactless behavior towards Dai-yu and made an effort to make amends. Slowly and gently he was able to soften Dai-yu and she forgave him. In time, as his love for Dai-yu grew, he became more and more mindful of putting her feelings before his own.

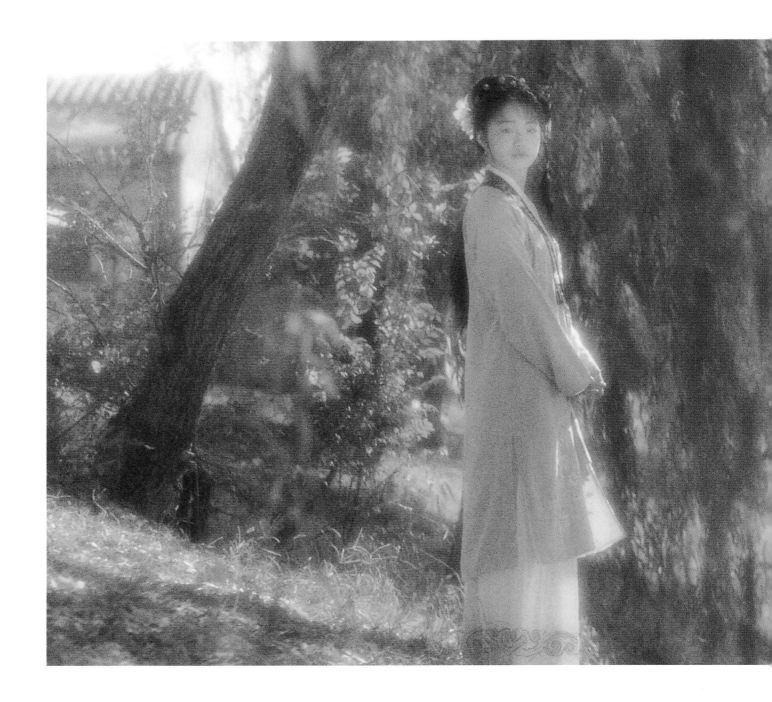

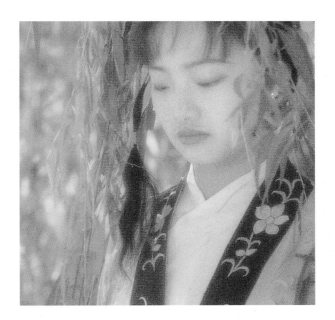

\mathcal{B}ao-yu studied his cousin intently. Her frail beauty reminded him of a flower reflected in a pond and her movements like a pliant willow dancing in the breeze. "I have met my cousin before," he finally declared.

Bao-yu was born with a bright translucent jade in his mouth. It was, in fact, the form taken by the Divine Stone but no one had a clue of its origin.

RIGHT:
Bao-yu and Lin Dai-Yu

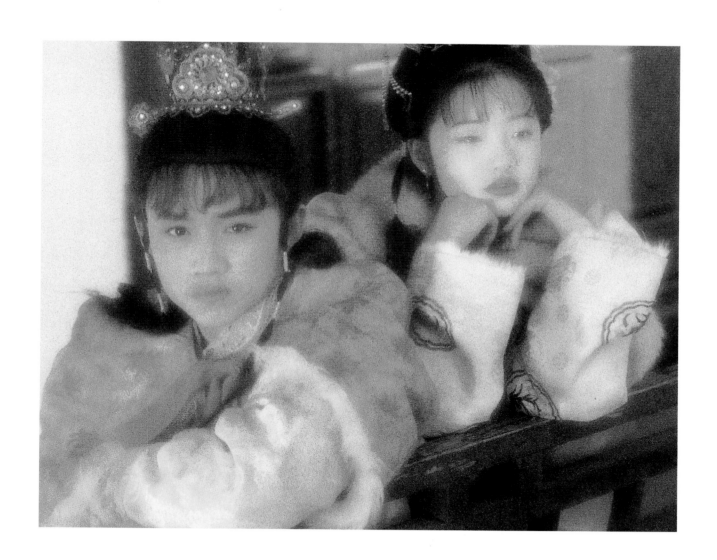

The plum blossoms were in full bloom and the family convened in the Garden of Concentrated Fragrance at Ning Mansion to enjoy the flowers. Bao-yu became weary and wanted a nap. Qin-shi, the wife of one of the great-grandsons, took charge and lead Bao-yu and his party of attendants to her room. Bao-yu felt it was heavenly to rest in a room enchantingly fit for an immortal. Qin-shi covered him with a fine silk coverlet and he fell asleep as soon as he closed his eyes. In his dream he saw Qin-shi and pursued her a long way through crimson columns, marble steps, verdant trees and crystal streams. Surely such a pristine place as this had never before been traveled by a human.

Bao-yu was thinking of how he would like to spend the rest of his life here and give up all worldly ties when he heard someone singing from the other side of a hill:

Springtime dreams like drifting clouds disperse.

Petals caught by a flood none can reverse.

So tell young lovers to heed my plea.

It's foolish to court love's misery.

Before the song ended Bao-yu beheld the songstress — a vision of immortal loveliness and grace. He greeted the apparition with a bow. "Sister Fairy, please tell me where you are from and where might you be going? I have lost my way. Would you kindly be my guide?"

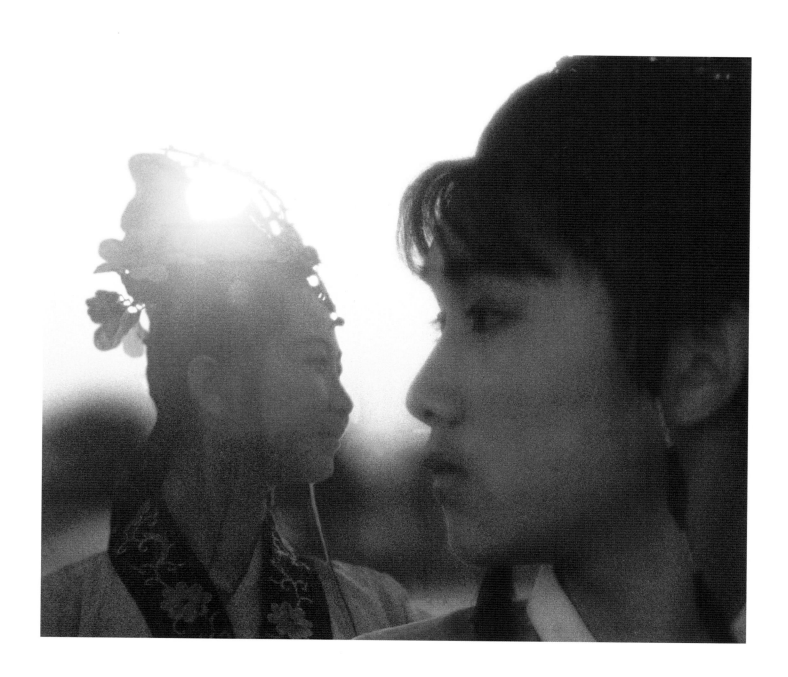

"I live in the Land of Illusion above the Sphere of Parting Sorrow in the Sea of Brimming Grief," she answered. "I am the Goddess of Disenchantment from the Grotto of Emanating Fragrance on the Mountain of Expanding Spring. I watch over all romances, unrequited love, women's sorrows and men's lustful passions. A great number of reincarnated beings have gathered here in the Land of the Red Dust and I've come to issue them love and longing. It is not by chance that we have met today. You are a part of this event.

"Will you follow me to my home? I can offer you a cup of fairy tea, a pitcher of wine which I have brewed myself, and my singers and dancers will entertain you with twelve new songs called 'Dream of the Red Chamber'."

Bao-yu, in his wonderment, had already forgotten about the whereabouts of Qin-shi. He followed Disenchantment through an archway inscribed: Illusory Land of Great Void. Ahead was a Palace gateway which was inscribed: Sea of Grief and Heaven of Love. The couplet beside it read:

Firm as earth and lofty as heaven,

passion from time immemorial knows no end;

Pity silly lads and plaintive maids hard put to it

to requite debts of breeze and moonlight.

"Well," said Bao-yu to himself, "this interests me but I don't know the meaning of 'debts of breeze and moonlight' and I know nothing of 'passion from time immemorial'. I shall make it a point to discover what they are."

Simply by thinking these thoughts Bao-yu unknowingly unlocked the door of his heart to evil. Still, in a state of excitement he followed Disenchantment through a number of gates and halls. He was so hurried he couldn't read all of the inscriptions but he did take note of a few: Board of Spring Longing, Board of Autumn Sorrows, Board of Morning Tears, Board of Night Sighs.

Finally he stopped Disenchantment and persuaded her to allow him to inspect the registers of records contained in these halls. But the words he found there were so

cryptic he couldn't grasp their meaning. The Goddess, knowing his quick intelligence, hurried him on before he unlocked the secrets of Heaven.

"Why puzzle over silly riddles when there is so much more to see? Follow me," she said. She took him through jade palaces with brilliant red chambers, golden floors, carved beams, and gardens of fairy flowers and herbs. Finally she called out, "Come and welcome your honored guest!"

Out came several fairy spirits who greeted Bao-yu with disappointment and disgust. "We've been awaiting the arrival of the spirit of our sister Vermilion Pearl. Why have you brought us this filthy creature to taint our precious domain?"

These words made Bao-yu feel dirty and he tried to hide. But Disenchantment gently took his hand and explained. That morning, she told them, she went to fetch Vermilion Pearl for a visit. She set off to Rong Mansion and in passing, ran into the spirits of Bao-yu's ancestors. They pleaded with her to take the headstrong and eccentric young boy instead and try to enlighten him. They felt he was the only hope among their heirs to save their declining family's fortune.

"In sympathy to their request I brought Bao-yu here and allowed him to look at the registers concerning records of the girls of his household. When he failed to understand that, I brought him here to teach him the illusions of love in hope of setting him on the right path and awakening him to truth."

With that Disenchantment poured Bao-yu a cup of A Thousand Red Flowers in One Cavern tea while little maids served amber cups of ambrosia. Bao-yu was introduced to the fairies, whose names were Fairy of Amorous Dreams, Great Mistress of Passion, Golden Maid Bringing Grief, and the Saint of Transmitted Sorrow. Dancing girls stepped forward to perform the twelve songs of "Dream of the Red Chamber." Disenchantment poured a cup of wine and handed Bao-yu a manuscript to follow along. She was certain no poor mortal would appreciate the songs' subtle qualities and understand their meaning.

Bao-yu followed Disenchantment through a number of gates and halls.
He was so hurried he couldn't read all the inscriptions but he did take
note of a few: Board of Spring Longing, Board of Autumn Sorrows,
Board of Morning Tears, Board of Night Sighs.

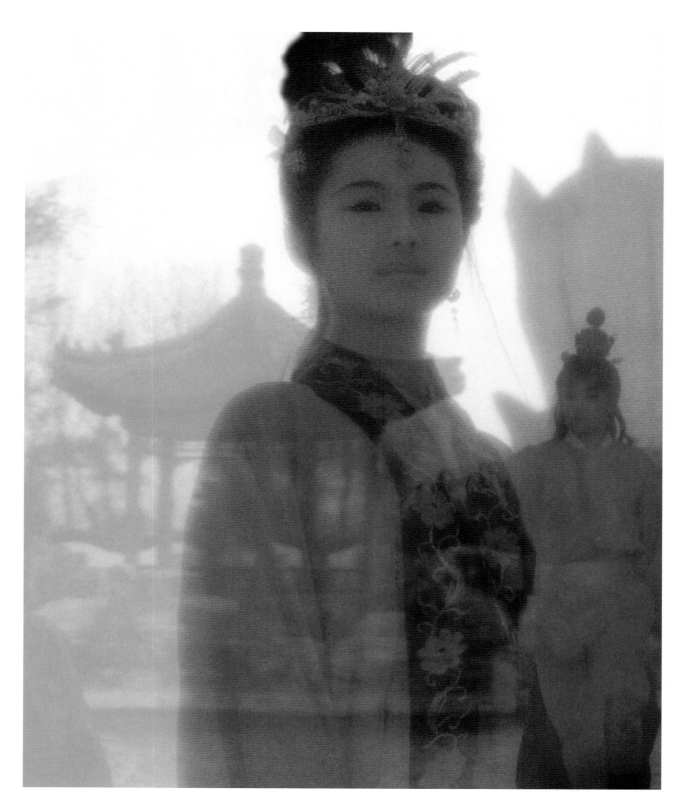

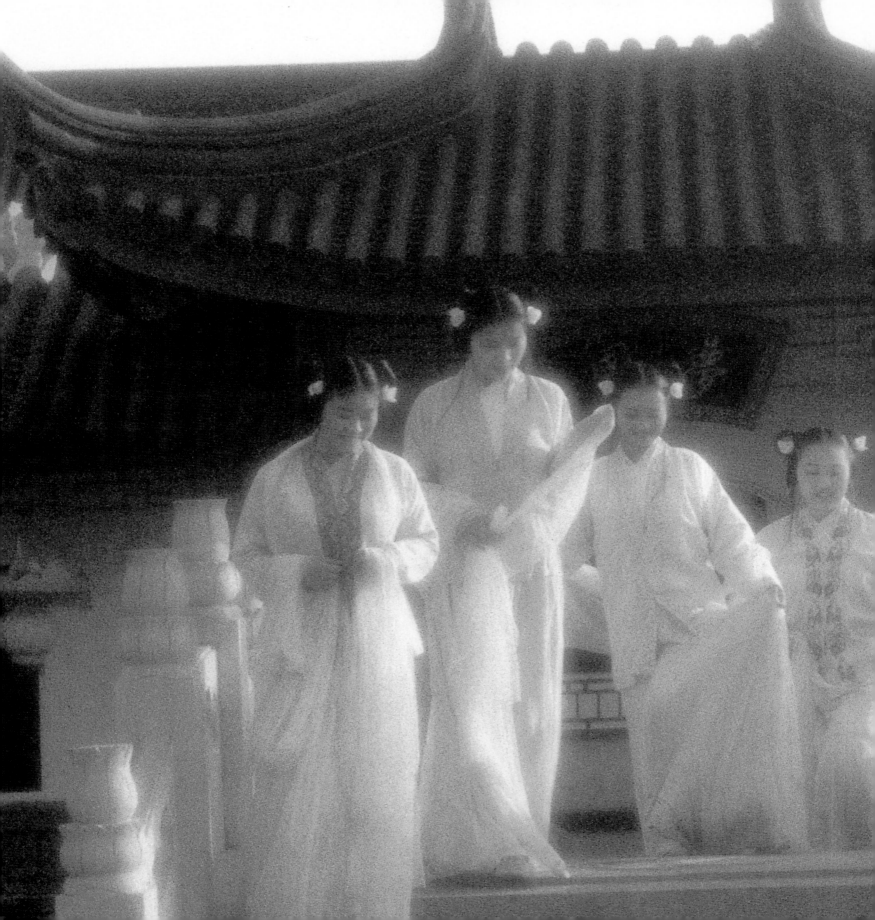

Prologue

DREAM OF THE RED CHAMBER

At the dawn of creation
Who sowed the seeds of love?
From the strong passion of
breeze and moonlight they came.
So in this world of sweet longing
On a day of distress,
in an hour of loneliness,
Fain would I impart my senseless grief
By singing this Dream of the Red Chamber
To mourn the Gold and the Jade.

LEFT:
*Dancing girls stepped out to perform the twelve songs of
"Dream of the Red Chamber"*

First Song

A LIFE MISSPENT

Well-matched, all say, the Gold and the Jade;
I alone can recall the pledge between plant and stone.
Vainly facing the hermit in sparkling snow-clad hills
I forget not the fairy in lone woods beyond the world.
I sigh, learning that no man's happiness is complete:
Even a pair thought well-matched
May find disappointment.

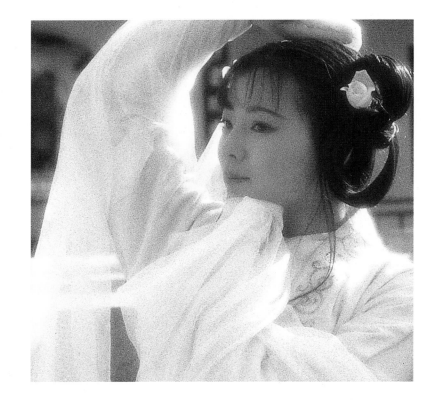

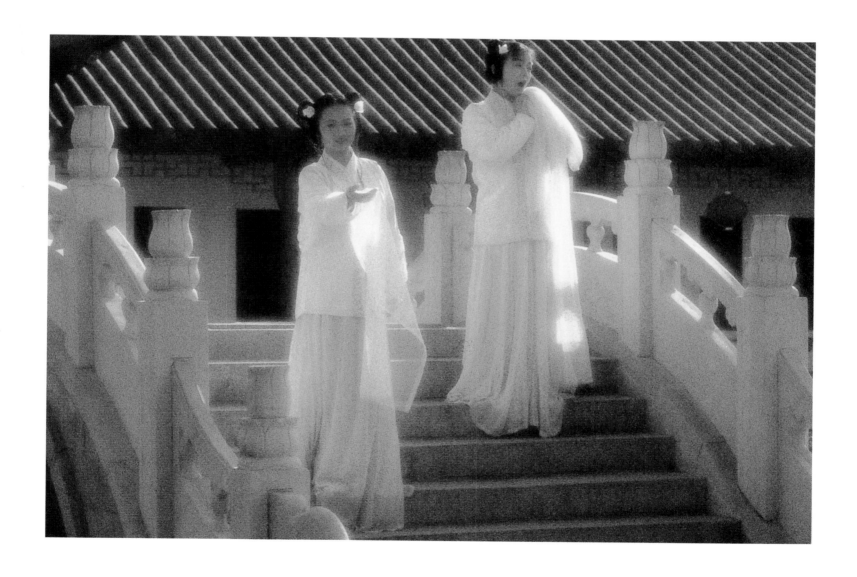

Second Song

VAIN LONGING

One is an immortal flower of fairyland,

The other fair flawless jade,

And were it not predestined

Why should they meet again in this existence?

Yet, if predestined

Why does their love come to nothing?

One sighs to no purpose,

The other yearns in vain;

One is the moon reflected in the water,

The other but a flower in the mirror.

How many tears can well from her eyes?

Can they flow on from autumn till winter,

From spring till summer?

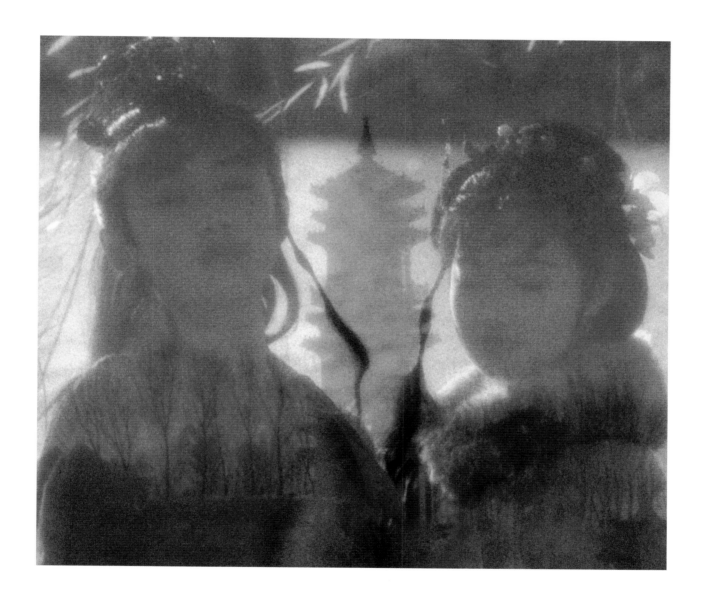

Third Song

THE TRANSIENCE OF LIFE

At the height of honor and splendor
Death comes for her;
Open-eyed, she has to leave everything behind
As her gentle soul passes away.
So far her home beyond the distant mountains
 That in a dream she finds and tells her parents:
"Your child has gone now to the Yellow Spring;
You must find a retreat before it is too late."

Fourth Song

SEPARATION FROM DEAR ONES

Three thousand *li* she must sail through wind and rain,
Giving up her home and her own flesh and blood;
But afraid to distress their declining years with tears
She tells her parents: "Don't grieve for your child.
From old good luck and bad have been predestined,
Partings and reunions are decreed by fate;
Although from now on we shall dwell far apart,
Let us still live at peace;
Don't worry over your unworthy daughter."

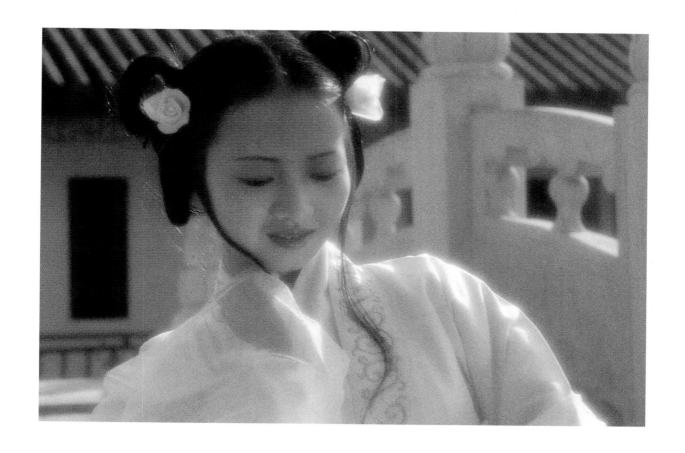

Fifth Song

SORROW AMIDST JOY

She is still in her cradle when her parents die,

Although living in luxury who will dote on her?

Happily she is born too courageous and open-hearted

Ever to take a love affair to heart.

Like bright moon and fresh breeze in a hall of jade

She is matched with a talented and handsome husband;

May she live with him for long years

To make up for her wretched childhood!

But over the Kaotang Tower the clouds disperse,

The river Hsiang runs dry.

This is the common fate of mortal men,

Useless it is to repine.

Sixth Song

SPURNED BY THE WORLD

By nature fair as an orchid,
With talents to match an immortal,
Yet so eccentric that all marvel at her.
To her, rich food stinks,
Silken raiment is vulgar and loathsome;
She knows not that superiority fosters hatred,
For the world despises too much purity.
By the dim light of an old shrine she will fade away.
Her powder and red chamber, her youth and beauty wasted.
To end, despite herself, defiled on the dusty road —
Even as flawless white jade dropped in the mud.
In vain young scions of noble houses will sigh for her.

Seventh Song

UNION OF ENEMIES

A mountain wolf, a savage beast,
Mindless of past obligations
Gives himself up to pride,
luxury and license,
Holding cheap the charms of a
noble family's daughter,
Trampling on the precious child
of a ducal mansion.
Alas, in less than a year
her sweet soul fades away.

RIGHT:
*Bao-yu and the Fairy
of Amorous Dreams*

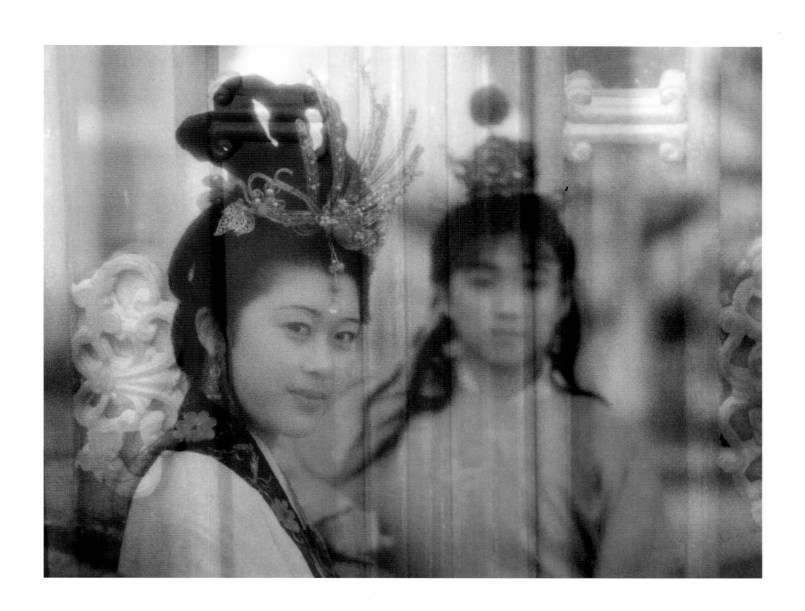

Eighth Song

PERCEPTION

OF THE TRANSIENCE OF FLOWERS

She will see through the three Springs

And set no store

By the red of peach-blossom,

the green of willows,

Stamping out the fire of youthful splendor

To savor the limpid peace of a clear sky.

Though the peach runs riot against the sky,

Though the clouds teem with apricot blossoms,

Who has seen any flower that

can win safely through Autumn?

Even now mourners are lamenting

by the groves of poplars,

Ghosts are wailing below green maples,

And the weeds above their graves

stretch to the skyline.

Truly, changes in fortune are the cause

of man's toil,

Spring blooming and autumn withering

the fate of flowers.

Who can escape the gate of birth,

the fate of death?

Yet in the west, they say, grows the *sal* tree

Which bears the fruit of immortality.

Ninth Song
RUINED BY CUNNING

Too much cunning
in plotting and scheming
Is the cause
of her own undoing;
While yet living
her heart is broken
And after death all her
subtlety comes to nothing.
A rich house,
all its members at peace,
Is ruined at last and scattered;
In vain her anxious thought
for half a lifetime,
For like a disturbing dream
at dead of night,
Like the thunderous collapse
of a great mansion,
Or the flickering of a lamp
that gutters out,
Mirth is suddenly changed
to sorrow.
Ah, nothing is certain
in the world of men.

Tenth Song
A LITTLE ACT OF KINDNESS

Thanks to
one small act of kindness
She meets by chance
a grateful friend;
Fortunate that her
mother has done some
unnoticed good.
Men should rescue the
distressed and aid the poor,
Be not like her heartless
uncle or treacherous cousin
Who for love of money forget
their own flesh and blood.
Truly, rewards and punishments
Are meted out by Heaven.

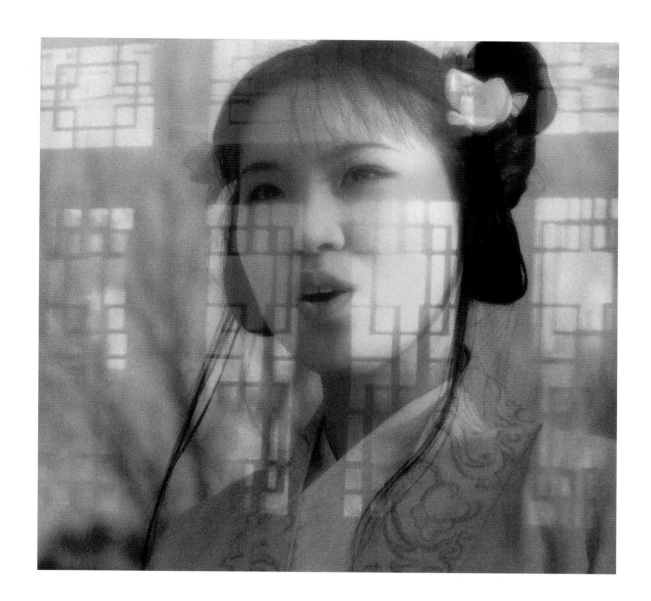

Eleventh Song

SPLENDOUR COMES TOO LATE

Love is only a reflection in a mirror,
Worse still rank and fame are
nothing but a dream,
So quickly youth and beauty fade away.
Say no more of embroidered curtains
and love-bird quilts,
Nor can a pearl tiara and phoenix jacket
Stave off for long Death's summons.
Though it is said that old age should be
free from want,
This depends on the unknown merits
laid by for one's children.
Jubilant in official headdress
And glittering with a gold seal of high office,
A man may be awe-inspiring and exalted,
But the gloomy way to the
Yellow Spring is near.
What remains of the generals and
statesmen of old?
Nothing but an empty name
admired by posterity.

Twelfth Song

GOOD THINGS COME TO AN END

Fragrant dust falls from painted beams
at the close of Spring;
By nature passionate and fair as the moon,
The true root is she of the family's destruction.
The decline of the old tradition starts with Ching,
The chief blame for the House's ruin rests with Ning.
All their sins come about through Love.

Epilogue

THE BIRDS SCATTER TO THE WOOD

An official household declines,

Rich nobles' wealth is spent.

She who did good escapes the jaws of death,

The heartless meet with certain retribution.

Those who took a life have paid with their own lives,

The tears one owed have all been requited in kind.

Not light the retribution for sins against others;

All are predestined, partings and reunions

Seek the cause of untimely death in a past existence,

Lucky she who enjoys rank and riches in old age;

Those who see through the world escape from the world,

While foolish lovers forfeit their lives for nothing.

When the food is gone the birds return to the wood;

All that's left is emptiness and a great void.

The fairies were about to continue their singing but the Goddess of Disenchantment could see that Bao-yu had completely lost interest.

"You don't understand any of this do you?" The Goddess sighed and shook her head. "Silly boy."

Bao-yu asked the fairies to stop singing. He said he was sleepy and blamed it on the wine. He could not see that the songs foretold the fates of the most beloved ladies in his life nor could he make any sense out of the songs at all. He was not a bit disenchanted with the illusory nature of idle pleasures and the Goddess had not awakened him to the vanity of love in the dusty world. Here in the Land of Illusion, he stood on the precipice of his childhood as Disenchantment made a final attempt to enlighten him with an initiation to a new world of earthly pleasures. So in a dream Bao-yu crossed a tender threshold into adolescence and received a road map to the future as well. He would awaken to life's journey in the Land of the Red Dust with only a faint echo of the oracular verses to guide him. In his ventures in both worlds he remains completely bemused — surely he will encounter Disenchantment again. No wonder they called him a "silly boy."

As it is written in stone:

Strange encounters take place in a secret dream,

For he is the most passionate lover of all time.